BIRDS FROM THE LOCKDOWN HIDE

BIRDS FROM THE LOCKDOWN HIDE

MARK MAGEE

FIRST EDITION

ISBNs
Paperback 978-1-80227-593-3
eBook 978-1-80227-594-0
Hardback 978-1-80227-595-7

CONTENTS

INTRODUCTION

During the first COVID lockdown in March 2020, the enforced lack of freedom required me to think about my photography. How could I pursue my passion for photographing wildlife and birds without contravening the new regulations regarding the safety of others and myself? What I needed was a different mindset because I've spent what seems a lifetime travelling the length and breadth of the country in pursuit of the common and elusive.

Occasionally in the past, I used a portable collapsible hide. I would take it with me, rolled up in the boot of the car, and more times than enough, that was where it would stay. I found it inhibited free movement and the ability to search, explore and enjoy the countryside and all it had to offer. Don't get me wrong; if I was at a location which had true potential, I would be happy to stay there all day – just not all of every day.

Could a permanent man-made hide be the answer, perhaps? It's isolated, non-intrusive, and, as a matter of necessity, private.

So I enquired with a long-standing friend and landowner about my desire to construct a hide to photograph the visiting birds on his farmland.

Thankfully, he and his father agreed to the proposed location and the construction of a permanent hide on their farm. Obviously, I had to be mindful that its siting would not interfere with the daily running of the farm, nor would it disturb the daily coming and going of visiting birds.

The introduction of lockdown in 2020 and the uncertainty of future events or happenings (let's face it, nobody knew what was really going to happen or how things would progress back then) became a paradigm moment for me: adapt or kiss the shutter button goodbye (allegorically speaking).

And so, with ultra-kind permission granted and the notion set, equipment and materials were moved to the site, and the execution of the lockdown hide came to fruition.

The hide has taught me new skills equipment-wise as well as a new way to observe the wildlife and the birds which feed and come to visit. I guess, above all else, I have learnt that patience has its virtues.

All the bird photographs refer to birds that visited the hide, and they have all been taken by myself.

You can follow me on Facebook:
www.facebook.com/markwildlifeNI

or Instagram:
markswildlife

CONSTRUCTION OF THE HIDE

I built the first hide out of wooden pallets, as you can see below.

MATERIALS USED

- 6 wooden pallets
- 3 2.5m x 1.5m camouflage tarpaulins
- 2m² of army camouflage netting
- An offcut of silage cover (heavy duty plastic)

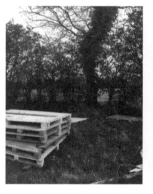
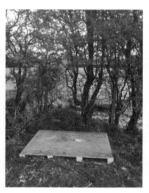
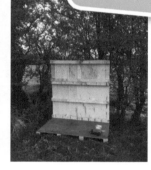
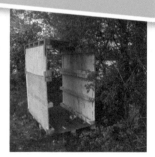

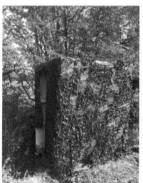

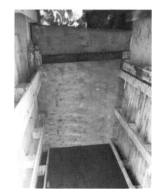

I made it as waterproof and windproof as I could. Its location was in the corner of the field, and it was surrounded by trees on both sides, so it was well sheltered on three sides. The left side looked out to the south, the right side to the north, and I had the west straight ahead of me.

The next things I needed to get in place were feeding points and perches. Ideally, I wanted to create a natural look as much as possible, so I endeavoured to use the timbers from around the area.

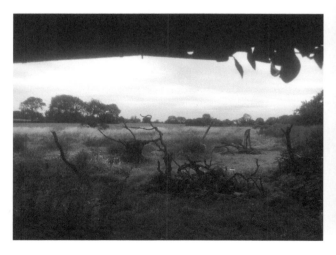

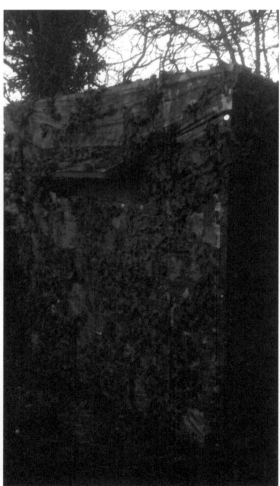

This structure suited my needs for seven months. I was reasonably well sheltered in it, even during the cold days of winter. However, an upgrade was required, so I began scanning the internet and Facebook marketplace for a suitable shed. Eventually, I found one that had a side door and an opening sash window and was 6ft × 4ft – a perfect size.

Arrangements were made, a trailer was acquired, and the shed was collected from Aughnacloy direction. The shed was assembled in place and covered just like the original pallet structure – with the camouflage covers and netting.

The seating in the original hide was two bar stools which a friend gave me, and although they served their purpose well, they did become a bit uncomfortable after a few hours. I decided it was time to find something a bit comfier and came up with the idea of getting a triple seat out of a transit or a similar van. I hunted around local car breakers but had no joy until a friend contacted me to say he would be breaking up a transit and I could have the seating.

I got this installed, and finally, I had everything I needed. I had a new shelter, complete with a bit more comfort for these old bones.

Over my time spent in the hide, I have learned so much about myself as a person and gained a better knowledge of my photography equipment. Being an angler, I always thought I was very patient, but nothing prepares you for sitting for hours in a hide waiting for that specific photograph or that first-time visitor to the feeders. This then leads you to try and think like your subject and see what you can do better for the next time.

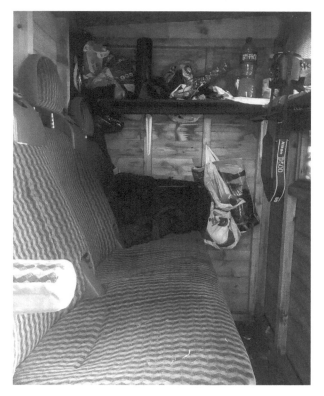

The equipment I have used has progressed over time as well. Originally, I photographed with a Nikon D7100 camera body with a Sigma 150-600 lens; however, now I am using a Nikon D500 body with a Nikon 200-500 lens and a Nikon 300PF prime lens.

I am self-taught through trial and error and have found that YouTube is a great learning aid. I have a greater understanding of my equipment and settings. I can shoot with higher ISO settings and lower shutter speeds. i.e. 1/25 for low light photography. This is an excellent advantage of DSLR cameras, as you can rattle off 300-500 shots in a day. Could you picture trying to do this in the film days?

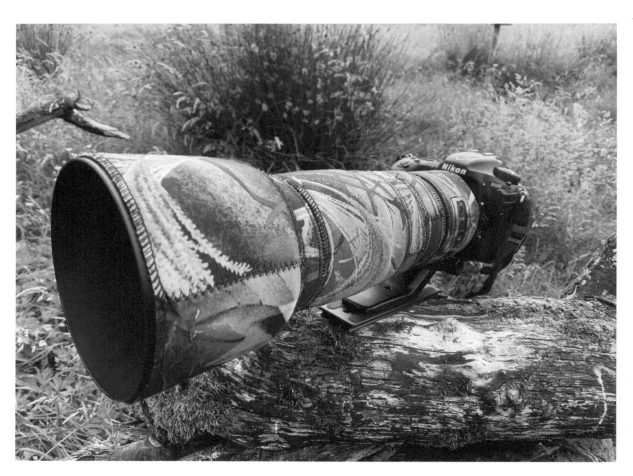

Nikon D500 camera with a Nikon 200-500 f5.6 Lens

FEEDING

I feed the birds the following seeds and foods. I am also growing wildflowers along with sunflowers for some natural feeding.

For smaller birds:

- Sunflower hearts – these are full of energy and ideal for nearly all garden birds. You can put them in a feeder, on a bird table or simply sprinkle them on the ground. Sunflower hearts are now 'Fair to Nature' accredited.
- Peanuts and acorns – I collect these throughout the autumn for the Jays and smaller birds, along with cheese that has gone off in the fridge. Peanuts are normally only fed through the winter months as it has been reported that in springtime and during breeding, they can cause death by choking the chicks.
- Suet balls – these are a great food in winter when birds need high-fat foods in order to fight the cold over the chillier months.

For larger birds:

- Roadkill – I leave out any roadkill I find for the Buzzards, Magpies and Hooded Crows. I also feed them fresh chicken drumsticks (uncooked) as this is better for the birds. It is also better for the foxes and badgers that visit as the bones are softer, which reduces the chances of them choking on them as they are not as brittle.

Water:

- It's a good idea to provide water to drink and they can also use the water to clean themselves. Again, this doesn't need to be expensive or complicated: a shallow bowl with water is ideal. I have created a small water feature at the hide that covers the above and also doubles up as a small reflector for photography.

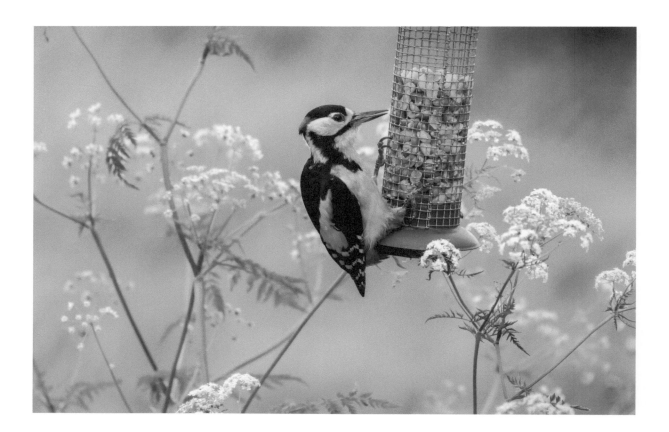

THE VISITING BIRDS

The next section contains all the birds that visit the hide on a frequent basis.

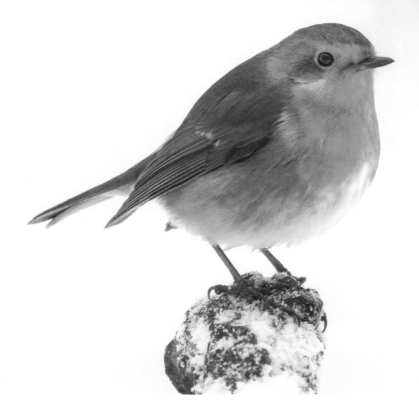

The European Robin is a small insectivorous songbird found across Europe, east to Western Siberia and south to North Africa. The male and female are similar in colouration, with an orange breast and face lined with grey, brown upperparts and a whitish belly. The bill and eyes are black. Juveniles are spotted brown and white in colouration, with patches of orange gradually appearing. Robins are very territorial birds and will viciously attack other robins that appear on their patch. A dispute starts with males singing at each other, trying to get a higher perch in order to show off their breasts most effectively. This usually ends the challenge.

DIMENSIONS (APPROX.):
- 12-13cm in length
- Weighing around 15-21g
- Wingspan of 20-22cm

DIET:
- Insects, spiders, worms, seeds and berries.

WHERE TO SEE THEM:
- Robins live across the UK in woodland, hedgerows, parks and gardens.

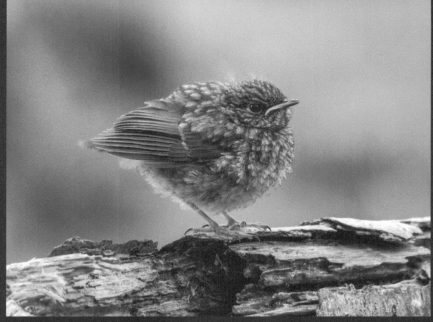

Juvenile Robin through the stages to adulthood

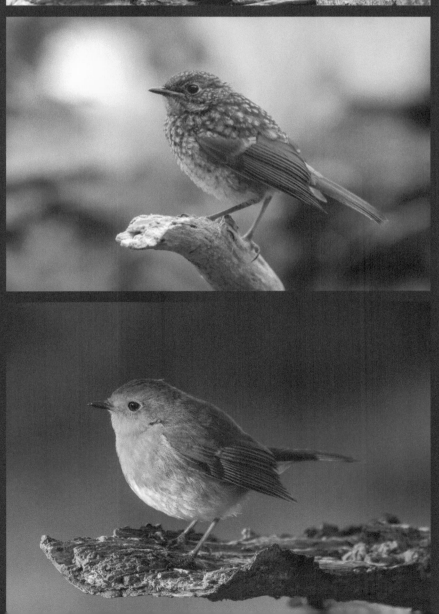

Blue Tit

A colourful mix of blue, yellow, white and green makes the Blue Tit one of our most attractive and most recognisable garden visitors. They nest in holes in trees but are just as happy to use nest boxes. Blue Tits are active feeders, hunting out insects and spiders among the smaller branches and leaves of trees in woodlands.

DIMENSIONS (APPROX.):

- 12cm in length
- Weighing around 11g
- Wingspan of 18cm

DIET:

- Insects, spiders and seeds.

WHERE TO SEE THEM:

- Blue Tits are common in woodland, hedgerows, parks and gardens. They are widespread and found across the whole of the UK.

Juvenile

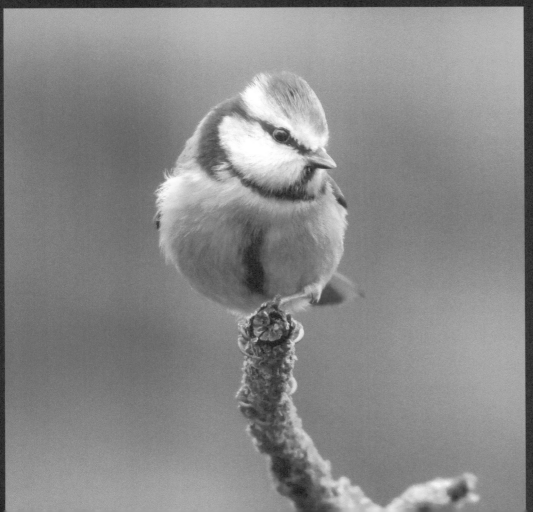

Adult

13

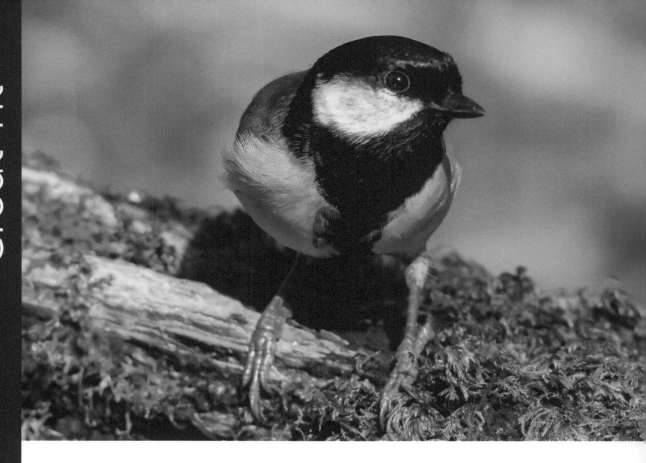

Great Tit

The Great Tit is the largest European tit. The crown, nape and throat are black, and the cheeks are white. The breast and belly are yellow, with a black stripe down the centre. There is a white wing bar across the blue-grey wings. The back is yellowish-green, and the rump is blue-grey. The legs are grey-blue, and the bill is black.

The sexes can be told apart by the width of the black stripe down the breast – the males have a broader stripe than the females. Juveniles are paler and duller, with yellowish cheeks and wing bars.

DIMENSIONS (APPROX.):

- 14cm in length
- Weighing around 18g
- Wingspan of 14cm

DIET:

- Insects, spiders and seeds.

WHERE TO SEE THEM:

- Great Tits can be seen in woodlands, parks and gardens across the UK. They are only absent from the Northern and Western Isles of Scotland.

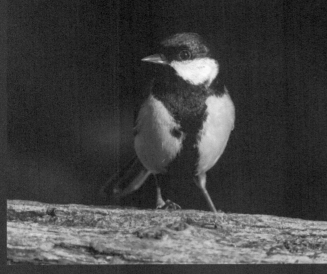

Male Tit

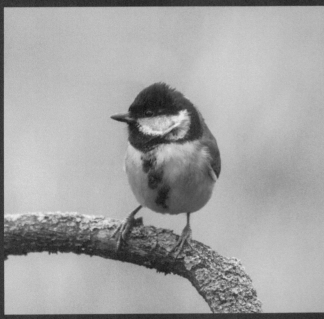

Female Tit

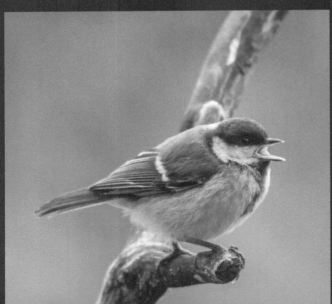

Juvenile Tit

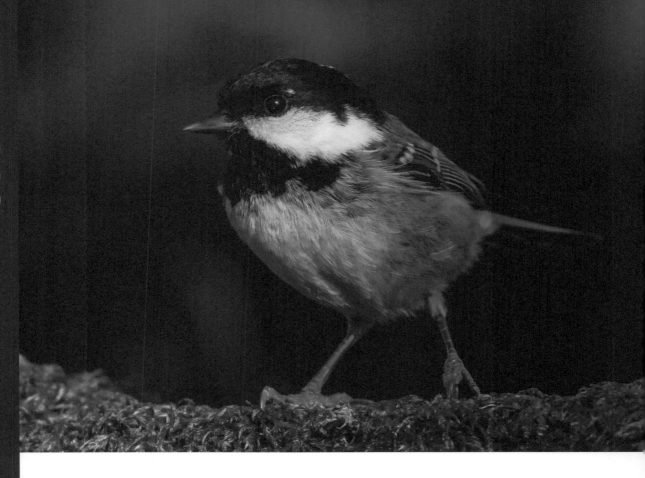

Coal Tit

Not as colourful as some of its relatives, the Coal Tit has a distinctive grey back, black cap, and white patch at the back of its neck. It's smaller, and the bill is more slender than those of Blue or Great Tits. Regular visitors to most feeders, they will take and store food to eat later. In winter, they join with other tits to form flocks that roam through woodlands and gardens in search of food.

I find the Coal Tits that visit the hide are very aggressive to each other. They will try to dominate other birds as and when they can.

DIMENSIONS (APPROX.):

- 11.5cm in length
- Weighing around 8-10g
- Wingspan of 17-21cm

DIET:

- Insects, spiders and seeds.

WHERE TO SEE THEM:

- Coal Tits can be seen in woodland, especially conifer woods, parks and gardens.

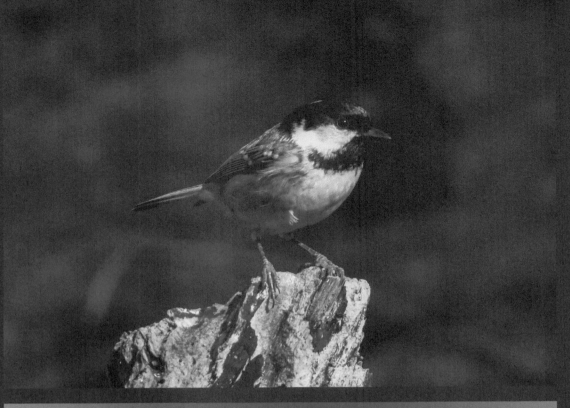

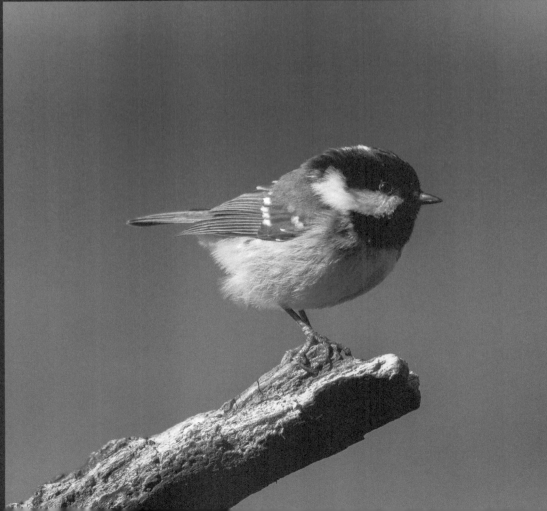

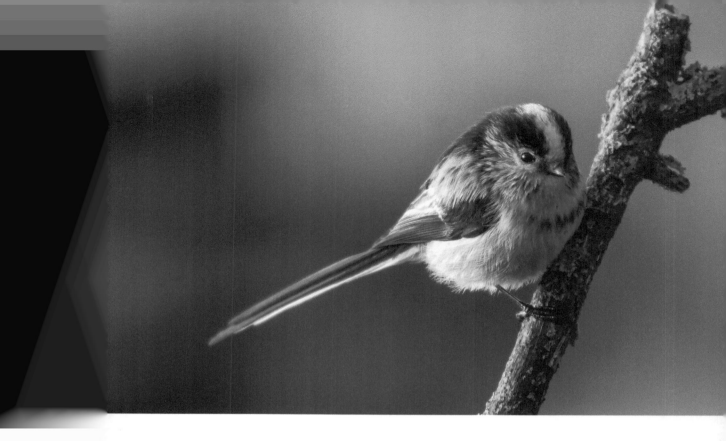

The Long-Tailed Tit is easily recognisable with its distinctive colouring, a tail which is bigger than its body, and undulating flight. Gregarious and noisy residents, Long-Tailed Tits are usually seen in small, excitable flocks of about 20 birds. Like most tits, they rove the woods and hedgerows but are also seen on heaths and commons with suitable bushes.

In my opinion, Long-Tailed Tits have to be the cutest of the tit families that visit the hide. I call them 'fluff balls,' others reference them as 'lollipop birds.' Their chattering and clicking sounds will let you know they are around.

DIMENSIONS (APPROX.):

- 14cm in length
- Weighing around 7-10g
- Wingspan of 16cm

DIET:

- Insects and occasionally seeds in autumn and winter.

WHERE TO SEE THEM:

- Long-Tailed Tits are found across the UK except for the far north and west of Scotland. They can be seen in woodland, farmland hedgerows, scrubland, parkland and gardens. In winter, they form flocks with other tit species.

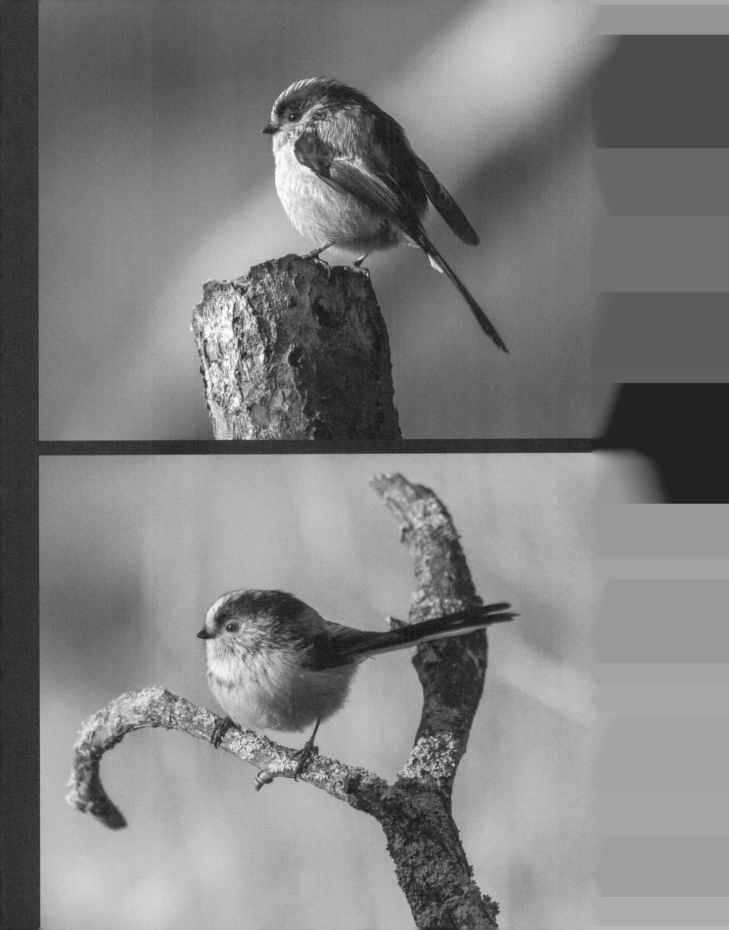

Goldfinch

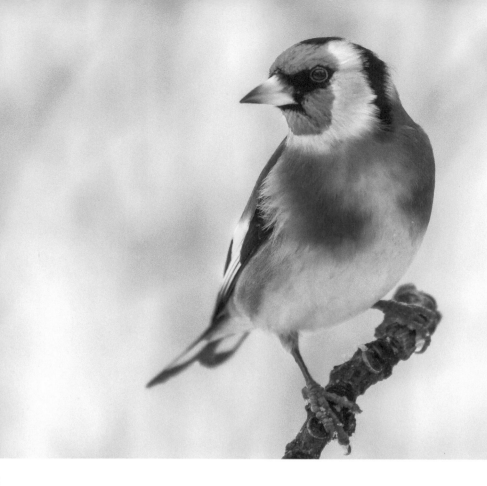

The Goldfinch is a highly coloured finch with a bright red face and a yellow wing patch. They are sociable, often breeding in loose colonies, and they have a delightful liquid twittering song and call. Their long, fine beak allows them to extract otherwise inaccessible seeds from thistles and teasels. Increasingly, they are visiting bird tables and feeders. In winter, many UK Goldfinches migrate as far south as Spain.

The Goldfinch has to be one of the nosiest feeders and also the most colourful of the finches that visit the hide. Did you know that a gathering of Goldfinches is referred to as a charm of Goldfinches?

DIMENSIONS (APPROX.):

- 12cm in length
- Weighing around 14-19g
- Wingspan of 21-25cm

DIET:

- Seeds and insects in summer.

WHERE TO SEE THEM:

- Goldfinches can be seen anywhere there are scattered bushes and trees, rough ground with thistles and other seeding plants. They like orchards, parks, gardens, heathland and commons.

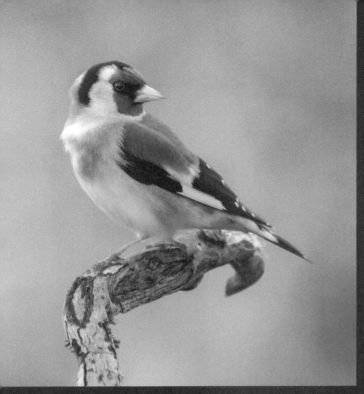
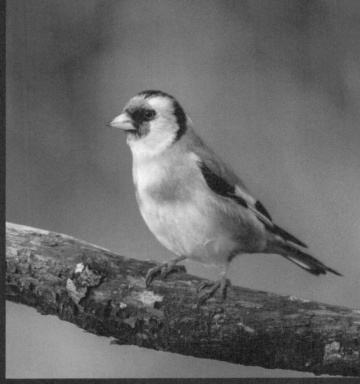

Male/Female Goldfinch

The red on the male's head travels beyond the eye, whereas you can see on the female it just stops at the eye.

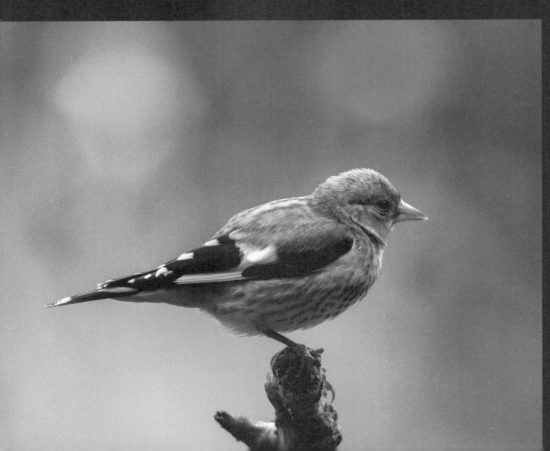

Juvenile Goldfinch

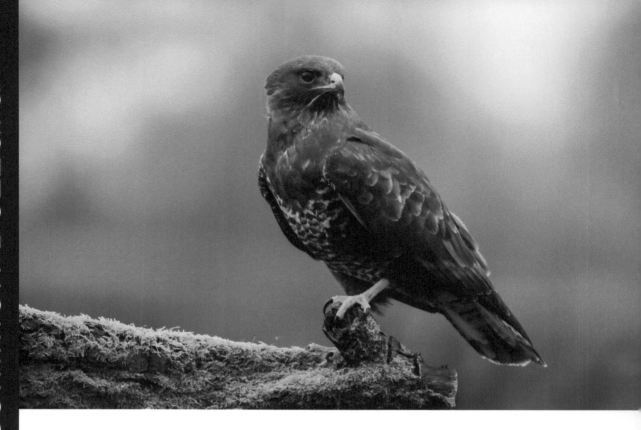

The Common Buzzard

The Buzzard seems very short-necked in flight and has a relatively short, broad tail and broad wings with fingers, which reduces turbulence. The wings are held in a shallow "V" when soaring. When perched, they look as though their head is hunched into the shoulders.

A Buzzard's plumage can be very varied, but it is typically dark brown above and below. The breast is finely barred and can be pale, and the underside of the wings and tail are pale. There is usually a pale band on the breast, and the tail is lightly barred. Juveniles are usually lighter underneath.

DIMENSIONS (APPROX.):

- 51-57cm in length
- Weighing around 550-1000g (male) and 700-1300g (female)
- Wingspan of 113-128cm

DIET:

- Buzzards are opportunistic predators and can catch a wide variety of prey. Small rodents such as voles and mice are commonly eaten, but they can also take prey as large as rabbits or as small as earthworms. They will also scavenge on roadkill. This flexible diet allows the Buzzard to survive in a variety of habitats. I initially attracted my Buzzards in with roadkill – rabbits and pheasants. I then started using fresh drumsticks staked out, and they loved them.

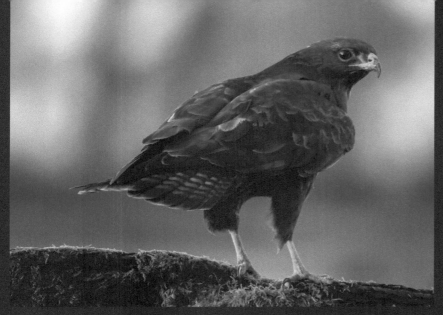

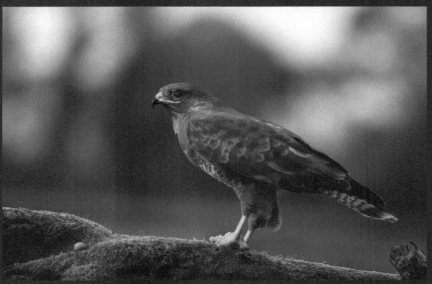

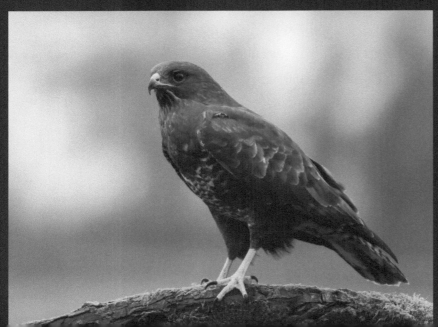

23

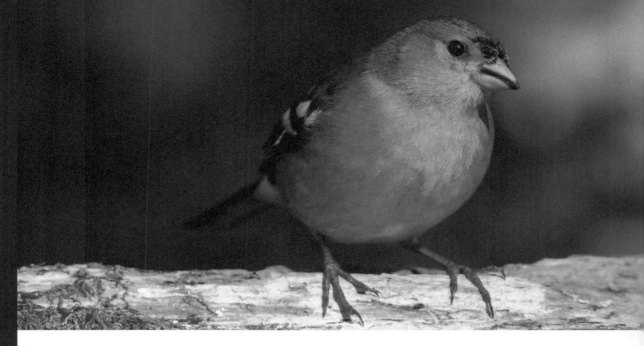

Chaffinch

The Chaffinch is our commonest finch and has striking double white wing bars. The wing bars are formed by white patches on the wing coverts and primary and secondary wing feathers. Its summer plumage is brighter than its winter plumage.

The male Chaffinch has a pink breast and cheeks, a blue-grey crown and nape, and a chestnut-brown back. In summer, its bill is grey-blue, turning to pale brown in the winter. The female has an olive-brown back and grey-brown underparts, becoming almost white towards the rump, which is greenish. The juveniles are similar to the female but lack the greenish rump. The bill is brown in both females and juveniles.

You will usually hear Chaffinches before you see them, with their loud song and varied calls. They let you know if the Sparrowhawks are about and warn the other birds that are feeding.

DIMENSIONS (APPROX.):
- 14.5cm in length
- Weighing around 18-29g
- Wingspan of 24.5-28.5cm

DIET:
- Seeds and insects, like caterpillars, during the breeding season. They do not feed openly on bird feeders, preferring to hop about under the bird table or the hedge.

WHERE TO SEE THEM:
- Chaffinches can be seen around the UK in woodlands, hedgerows, fields, parks and gardens anywhere.

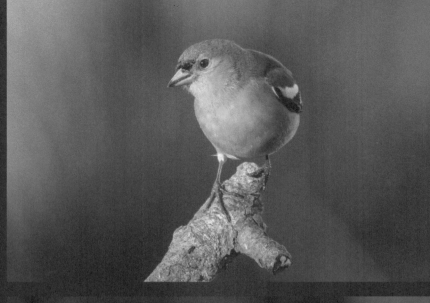

Male

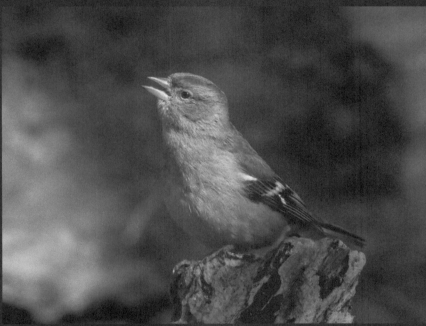

Female

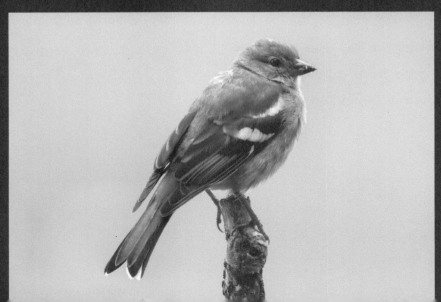

Juvenile

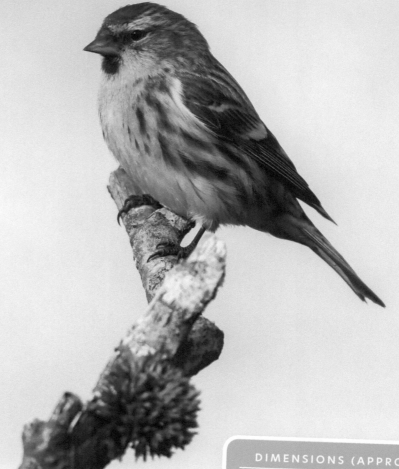

This tiny finch – only slightly bigger than a Blue Tit – is streaky and brown with patches of red on its head and sometimes its breast. They like to hang upside down in trees to feed.

I like the Redpoll as they are fast birds but will not take any nonsense from other feeding birds. Its attitude could be compared to 'small man syndrome.'

DIMENSIONS (APPROX.):

- 11.5cm in length
- Weighing around 11-12g
- Wingspan of 20-22cm

DIET:

- Seeds, particularly birch and alder, plus plants like willowherb and sorrel, but they also visit my bird feeders.

WHERE TO SEE THEM:

- Lesser Redpolls breed in woodland but also visit gardens. They can be seen dangling from tiny twigs in birch and alder trees or perhaps on shrub stems. This is a widespread breeding species.

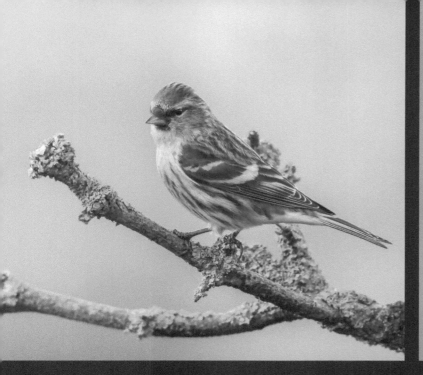

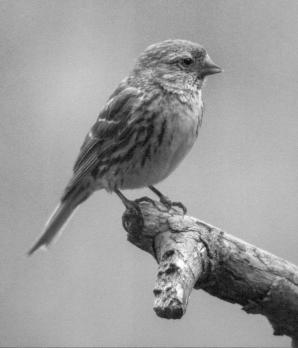

Male/Female Lesser Redpoll

The male is redder on the breast plumage compared to the female.

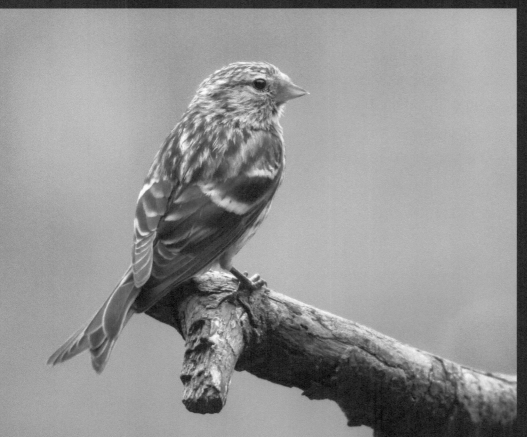

Juvenile

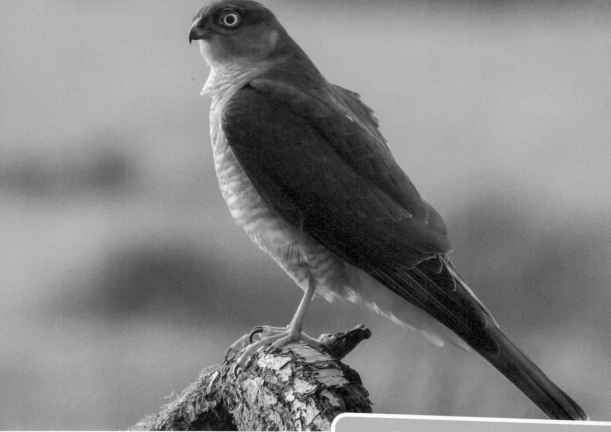

Sparrowhawks are small birds of prey. They are adapted for hunting birds in confined spaces like dense woodland, so gardens are ideal hunting grounds for them. Adult male Sparrowhawks have bluish-grey backs and wings and orangey-brown bars on their chests and bellies. Females and young birds have brown backs and wings and brown bars underneath.

Sparrowhawks have bright yellow or orangey eyes, long yellow legs and long talons. Females are larger than males, as with all birds of prey.

DIMENSIONS (APPROX.):

- 23-28cm in length
- Weighing around 110-196g (male) and 185-324g (female)
- Wingspan of 55-70cm

DIET:

- Mainly small birds. Males can catch birds up to thrush size, but females, being bigger, can catch birds up to pigeon size. Some Sparrowhawks catch bats. There are occasions I just see them flash through, trying to pick up a meal.

WHERE TO SEE THEM:

- Sparrowhawks breed in woodland but also visit gardens and more open country. They can be seen in towns and cities, as well as rural areas. Listen for the alarm calls of smaller birds as they spot a Sparrowhawk and will alert other birds in the area to the danger. Sparrowhawks are found in most places in the UK.

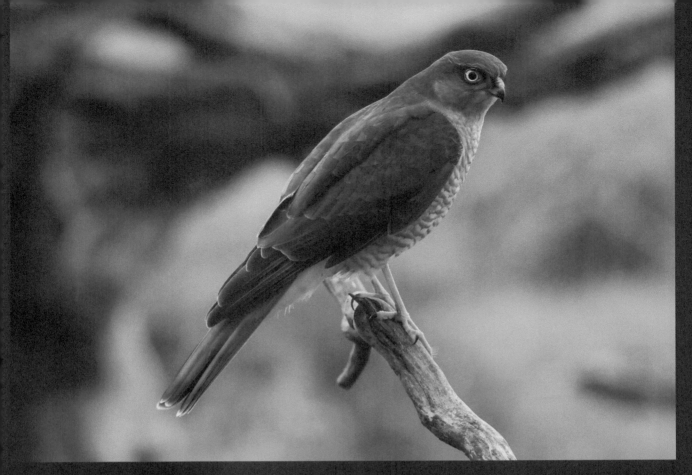

Male/Female Sparrowhawk

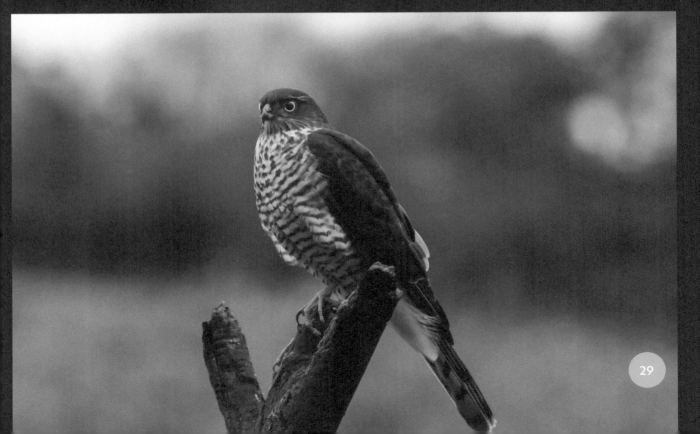

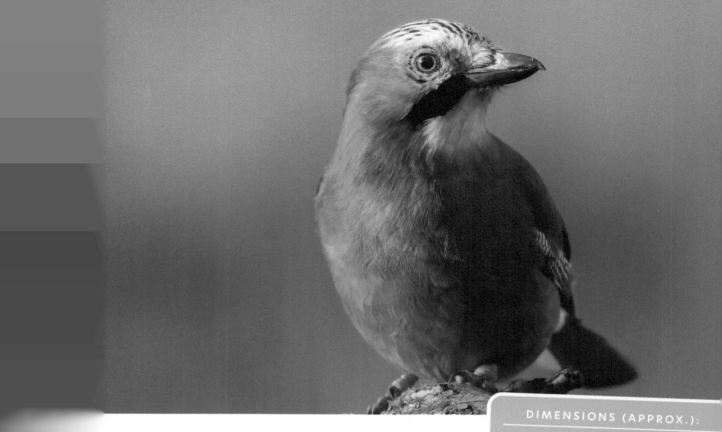

Although they are the most colourful members of the crow family, Jays are actually quite difficult to see. They are shy woodland birds, rarely moving far from cover. The screaming call usually lets you know a Jay is nearby, and it is usually given when a bird is on the move. Watch for a bird flying between the trees with its distinctive flash of white on the rump. Jays are famous for their acorn feeding habits, and in the autumn, you may see them burying acorns for retrieving later in the winter.

I now have four Jays in and around the hide. They are such characters as they have their own personalities.

DIMENSIONS (APPROX.):

- 34-35cm in length
- Weighing around 140-190g
- Wingspan of 52-58cm

DIET:

- Mainly acorns, nuts, seeds and insects, but they also eat nestlings of other birds and small mammals.

WHERE TO SEE THEM:

- You can find Jays across most of the UK, except in northern Scotland. They live in both deciduous and coniferous woodland, parks and mature gardens. Jays like oak trees in autumn when there are plenty of acorns. They are often seen flying across a woodland glade, giving their screeching call. They become more obvious in autumn when they may fly some distance in the open in search of acorns.

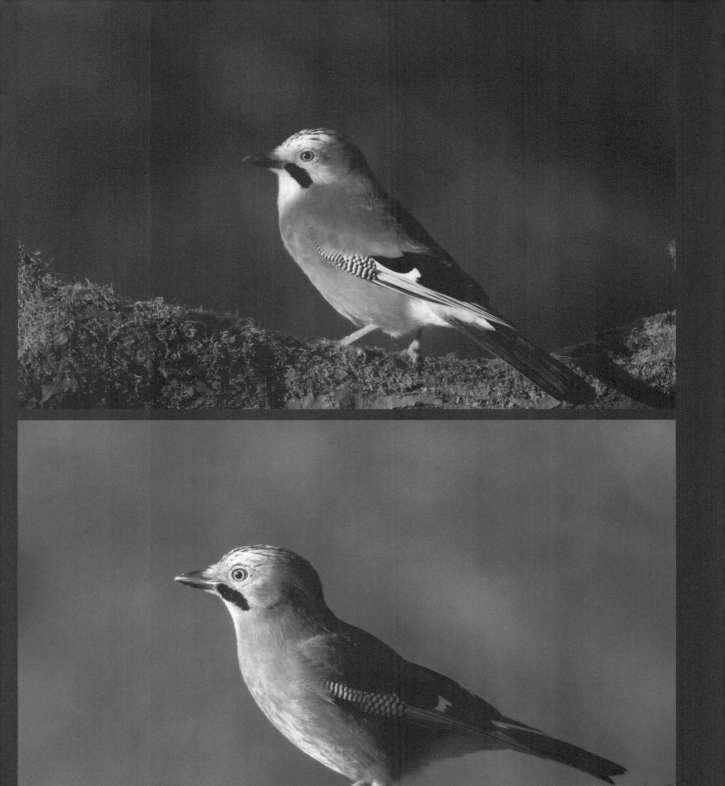

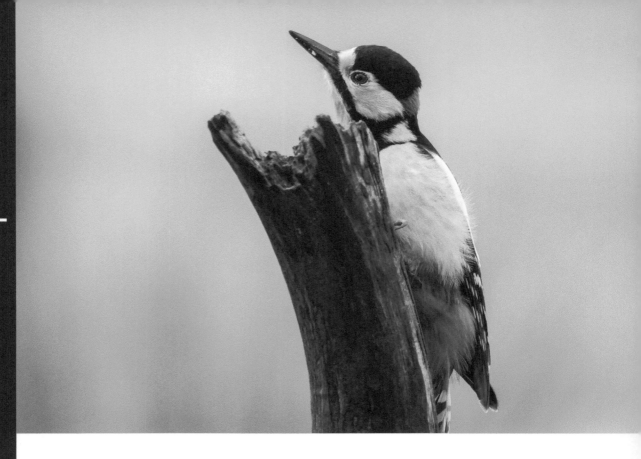

Great Spotted Woodpecker

The Great Spotted Woodpecker is blackbird-sized and striking black-and-white. It has a very distinctive bouncing flight and spends most of its time clinging to tree trunks and branches, often trying to hide on the side away from the observer. Its presence is often announced by its loud call or its distinctive spring 'drumming' display. The male has a characteristic red patch on the back of its head, and young birds have a red crown.

Great Spotted Woodpeckers are not regular visitors to the hide. They have only appeared around six times; however, it is nice to see them and get photographs of them when they do.

DIMENSIONS (APPROX.):

- 22-23cm in length
- Weighing around 85g
- Wingspan of 34-39cm

DIET:

- Insects, seeds and nuts.

WHERE TO SEE THEM:

- Great Spotted Woodpeckers can be seen in woodlands, especially with mature broad-leaved trees, although mature conifers will support them. They can also be found in parks and large gardens and will come to peanut feeders and bird tables. Only a handful of pairs nest in Ireland, but numbers are increasing.

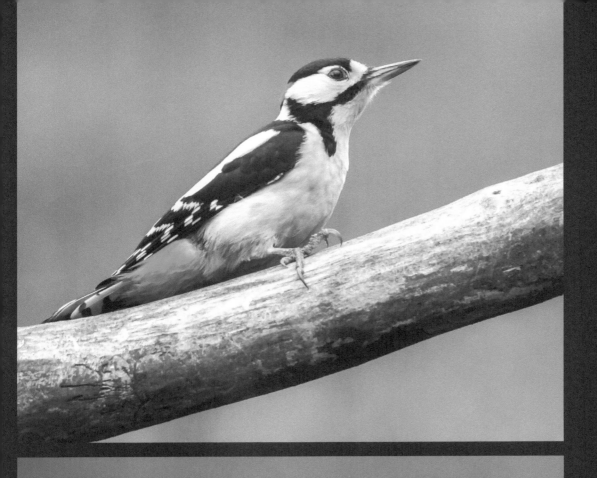

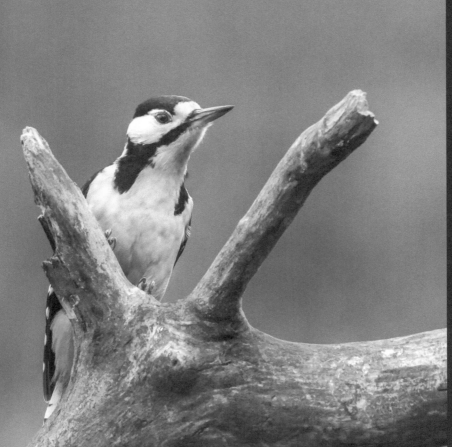

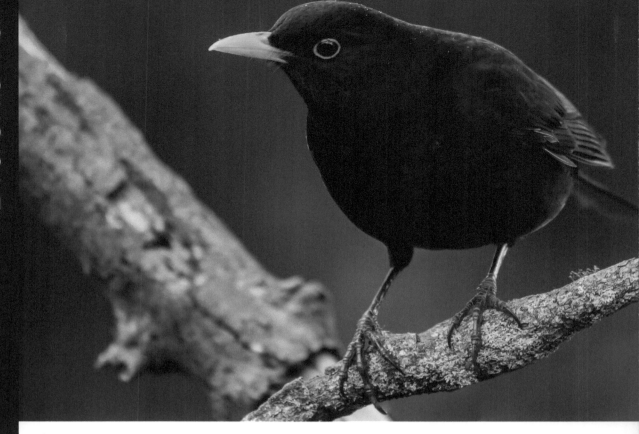

The males live up to their name, but confusingly, the females are brown, often with spots and streaks on their breasts. The bright orange-yellow beak and eye-ring make adult male Blackbirds one of the most striking garden birds. One of the most common UK birds, its mellow song is also a favourite.

The Blackbird will also warn if there is danger around. They will give an alarm if a bird of prey is in the area and will also call if there is a fox nearby.

DIMENSIONS (APPROX.):

- 24-25cm in length
- Weighing around 80-100g
- Wingspan of 34-38cm

DIET:

- Insects and worms but they also eat berries and fruit when in season.

WHERE TO SEE THEM:

- Blackbirds are found everywhere in gardens and the countryside.

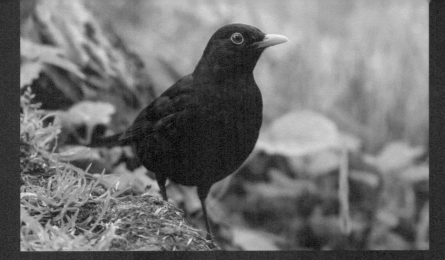

Male Blackbird

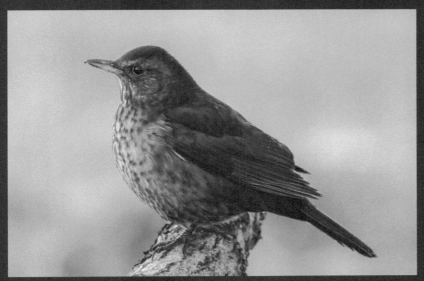

Female Blackbird

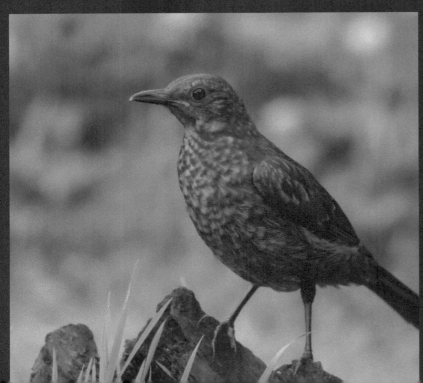

Juvenile

Wren

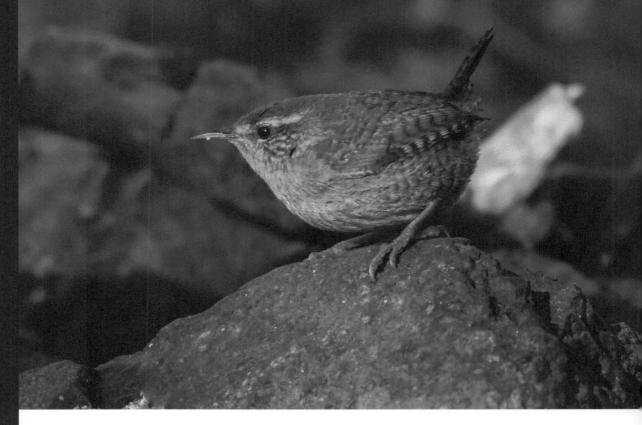

The Wren is a tiny brown bird, although it is heavier and not as slim as the even smaller Goldcrest. It is dumpy, almost round, with a fine bill, quite long legs and toes, very short round wings and a short, narrow tail which is sometimes cocked up vertically. For such a small bird, it has a remarkably loud voice. It is the most common UK breeding bird; however, numbers can sometimes suffer a decline during prolonged, severely cold winters.

The Wren is thought to be our smallest bird; however, in actual fact, the Goldcrest is, with a length of 9cm, a wingspan of 14cm and a weight of 6g.

DIMENSIONS (APPROX.):

- 9-10cm in length
- Weighing around 7-12g
- Wingspan of 13-17cm

DIET:

- Insects and spiders, plus I have seen them take seeds from the feeding station.

WHERE TO SEE THEM:

- Wrens can be found across the UK in a wide range of habitats – woodland, farmland, heathland, moorland and islands. Most are found in deciduous woodland, but it is least abundant in Scotland and northern England. They are a regular visitor to most gardens.

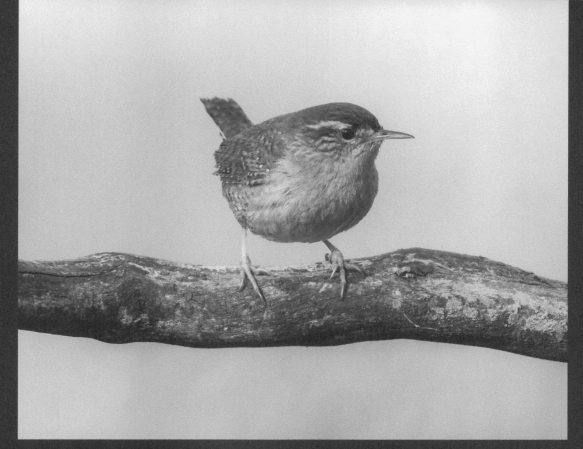

Adult Wren and Juvenile

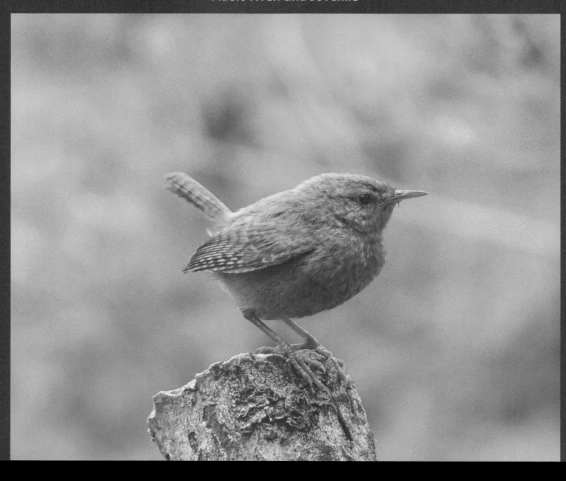

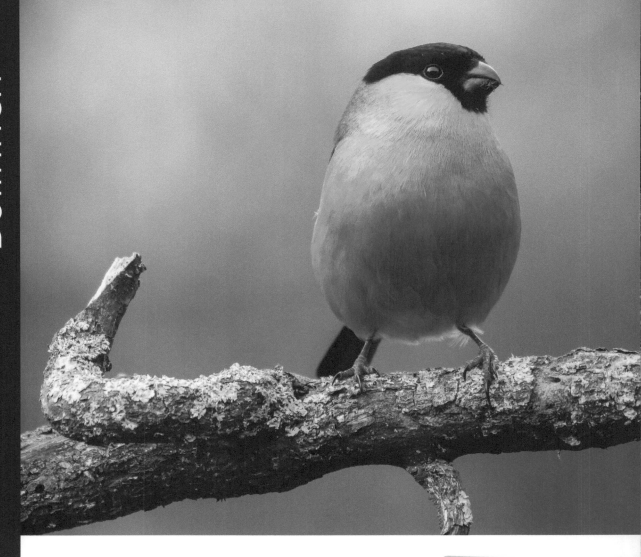

The male Bullfinch is unmistakable with his bright pinkish-red breast and cheeks, grey back, black cap and tail and bright white rump. The flash of the rump in flight and piping whistled call are usually the first signs of Bullfinches being present. They feed voraciously on the buds of various trees in spring and were once a 'pest' of fruit crops. The females are a washed-out brown colour, and the juveniles are coloured like the female until they mature.

DIMENSIONS (APPROX.):

- 14.5-16.5cm in length
- Weighing around 21-27g
- Wingspan of 22-26cm

DIET:

- Seeds, buds and insects (for their young).

WHERE TO SEE THEM:

- Bullfinches can be seen in woodlands, orchards and hedgerows. They are best looked for at woodland edges and usually located by their mournful calls.

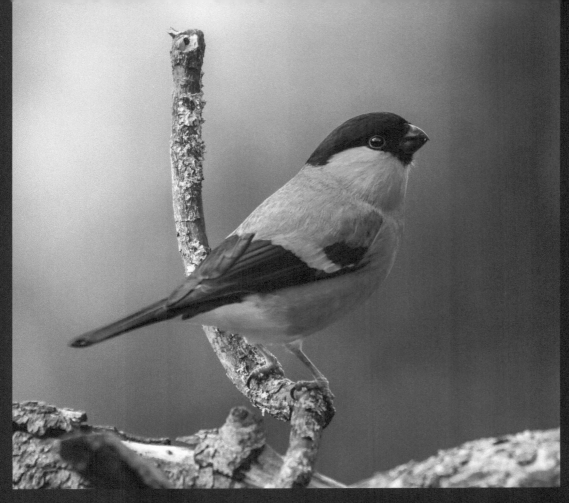

Male/Female Bullfinch

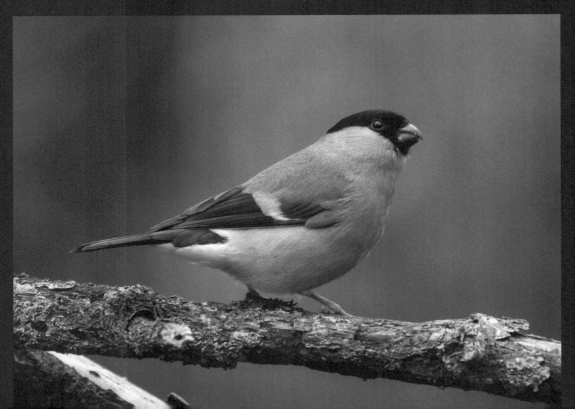

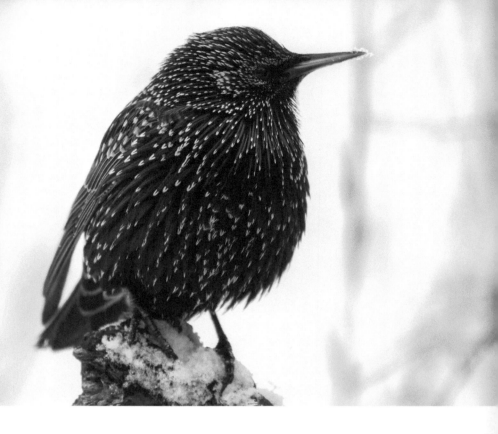

Starling

Smaller than Blackbirds, with a short tail, pointed head and triangular wings, Starlings look black at a distance, but when seen closer, they are very glossy with a sheen of purples and greens. Their flight is fast and direct, and they walk and run confidently on the ground. Noisy and gregarious, Starlings spend a lot of the year in flocks. They are still one of the commonest garden birds.

DIMENSIONS (APPROX.):

- 21cm in length
- Weighing around 75-90g
- Wingspan of 37-42cm

DIET:

- Invertebrates and fruit.

WHERE TO SEE THEM:

- Starlings are conspicuous and widespread in the UK. Still one of the UK's most prevalent garden birds. In winter, huge roosts can be found in plantations, reedbeds and city centres.

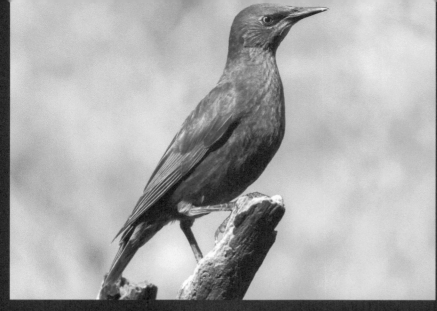

The stages to adulthood for the Starling

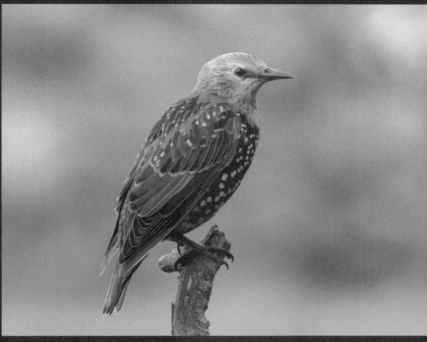

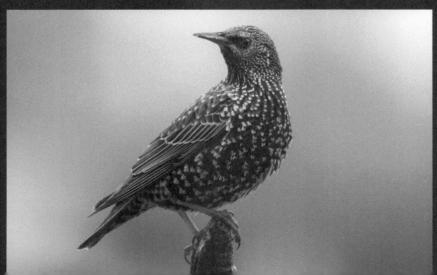

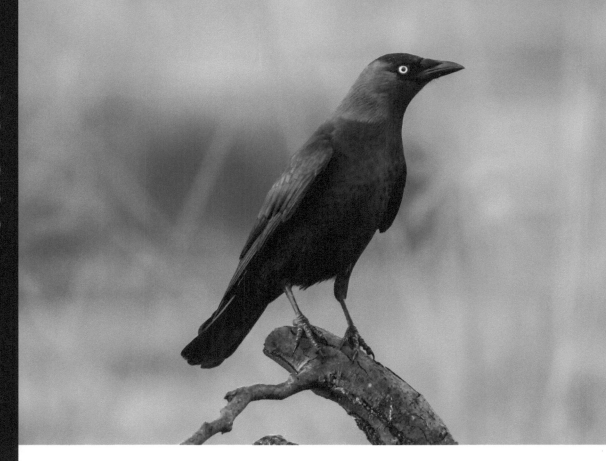

This is a small black crow with a distinctive, silvery sheen to the back of its head. The pale eyes are also noticeable. It will commonly nest in chimneys, buildings, rock crevices and tree holes.

DIMENSIONS (APPROX.):
- 34cm in length
- Weighing around 220g
- Wingspan of 70cm

DIET:
- Insects, young birds and eggs, fruit, seeds and scraps.

WHERE TO SEE THEM:
- Jackdaws can be found in fields, woods, parks and gardens. They are social birds and roost communally in woodlands. They are widespread and common across the UK.

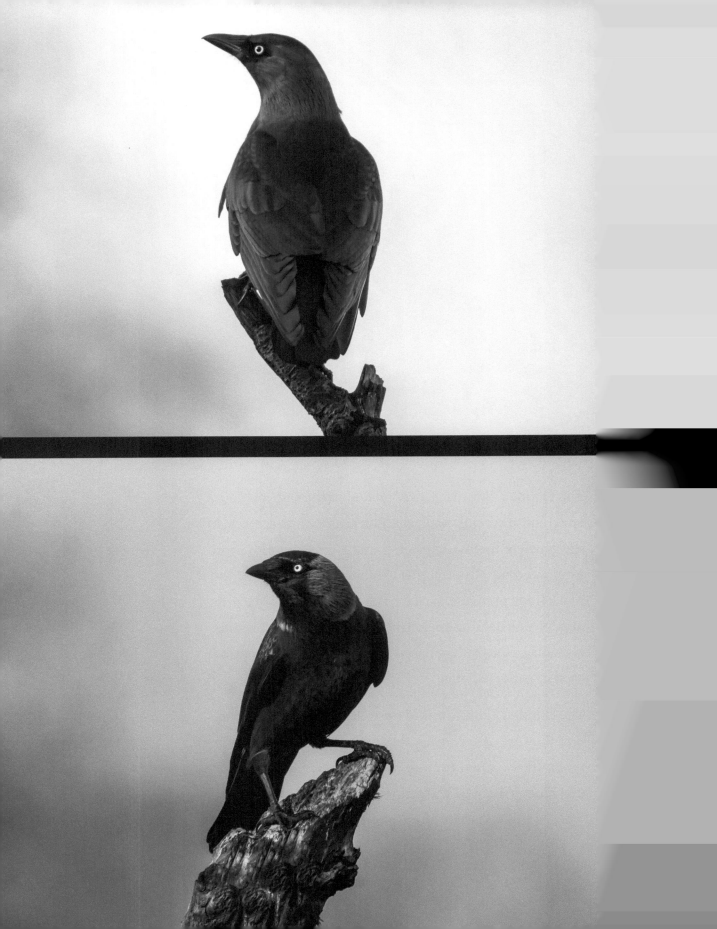

Hooded Crow

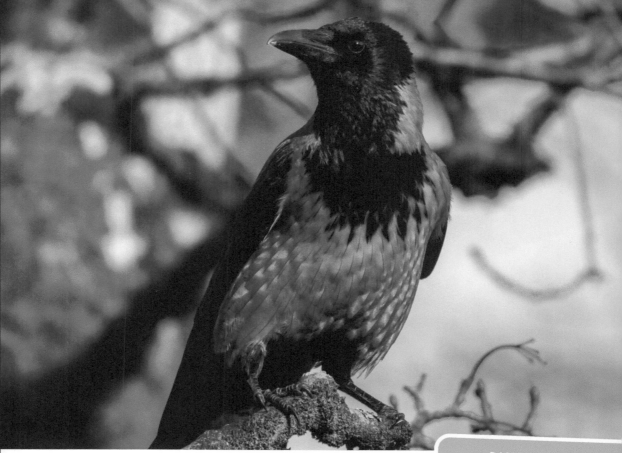

The Hooded Crow is closely related to the Carrion Crow, which until recently was regarded as the same species. In areas where the two species overlap, there may be some interbreeding, with hybrids exhibiting a mixed grey and black body plumage. Like Carrion Crows, Hooded Crows also feed on dead animals. Unlike crows, they can be more sociable in the feeding habits and groups of them may be seen together in fields.

The Hooded Crows around the hide are very wary of me, and they are also very aggressive towards the Buzzards when they come into feed. Most times, the Buzzards just ignore them. If you follow my Facebook page, you will see this action in some of the videos I have posted.

DIMENSIONS (APPROX.):

- 45-47cm in length
- Weighing around 370-650g
- Wingspan of 93-104cm

DIET:

- Omnivorous – includes carrion, invertebrates, grain, eggs and young birds.

WHERE TO SEE THEM:

- Hooded Crows can be found in north and west Scotland, Northern Ireland and on the Isle of Man, where it replaces the Carrion Crow. Most of the winter visitors come from Scandinavia.

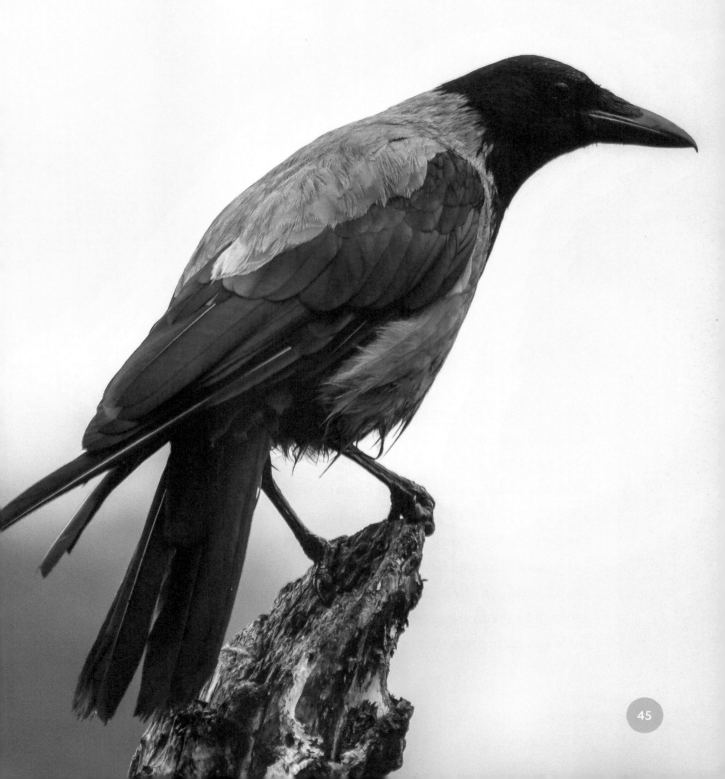

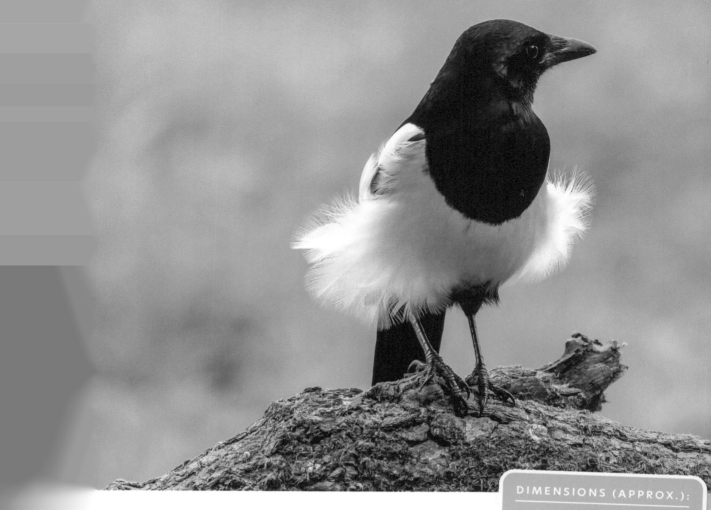

With its noisy chattering, black-and-white plumage and long tail, there is nothing else quite like the Magpie in the UK. When seen close-up, its black plumage takes on an altogether more colourful hue with a purplish-blue iridescent sheen to the wing feathers and a green gloss to the tail. Magpies seem to be jacks of all trades – scavengers, predators and pest-destroyers. Their challenging, almost arrogant attitude has won them few friends. Non-breeding birds will gather together in flocks.

DIMENSIONS (APPROX.):

- 44-46cm in length
- Weighing around 200-250g
- Wingspan of 52-60cm

DIET:

- Omnivorous – includes carrion.

WHERE TO SEE THEM:

- You can find Magpies across England, Wales and Northern Ireland. They are seen in a range of habitats from lowland farmland to high up in the glens.

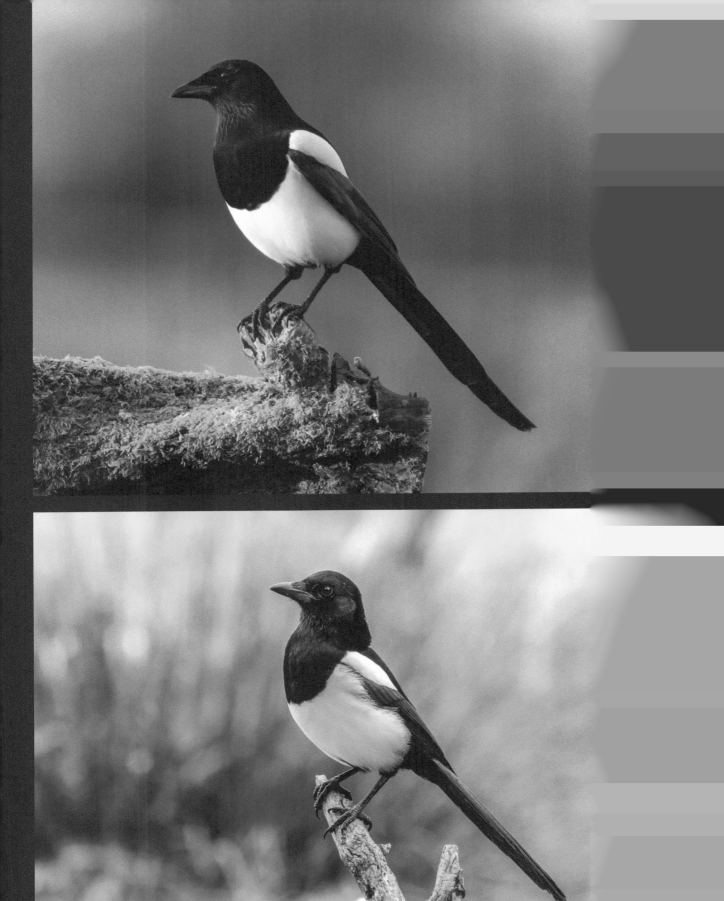

Greenfinch

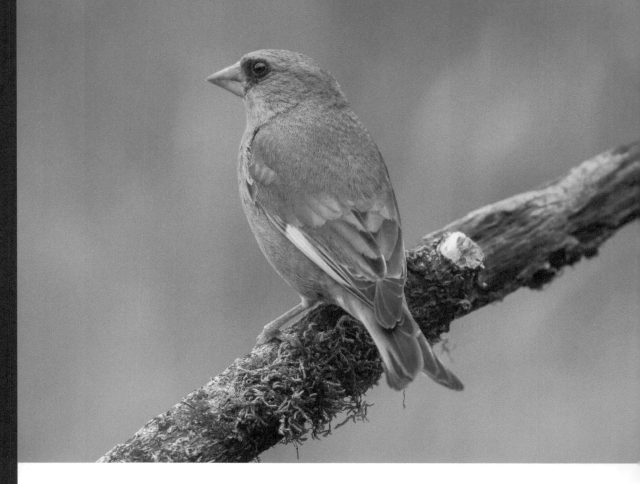

Its twittering, wheezing song and flash of yellow and green as it flies make this finch a truly colourful character. Nesting in a garden conifer or feasting on black sunflower seeds, the Greenfinch is a regular garden visitor, able to take advantage of food in rural and urban gardens. Although quite sociable, they may squabble among themselves or with other birds at the bird table.

It is nice to see the Greenfinches visit the hide. They have been in decline for many years; however, they seem to be making a comeback.

DIMENSIONS (APPROX.):

- 15cm in length
- Weighing around 28g
- Wingspan of 26cm

DIET:

- Seeds and insects.

WHERE TO SEE THEM:

- A common countryside bird found in woods and hedges, but mostly found close to people on farmland and in parks, town and village gardens and orchards.

Juvenile

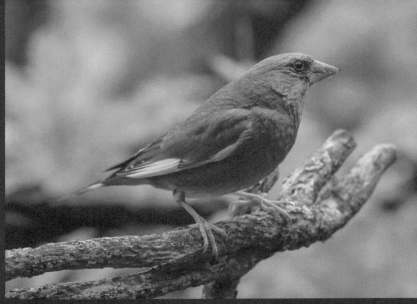

Male

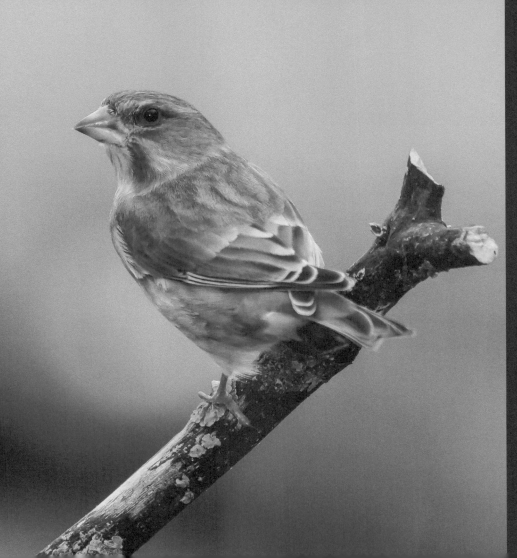

Female

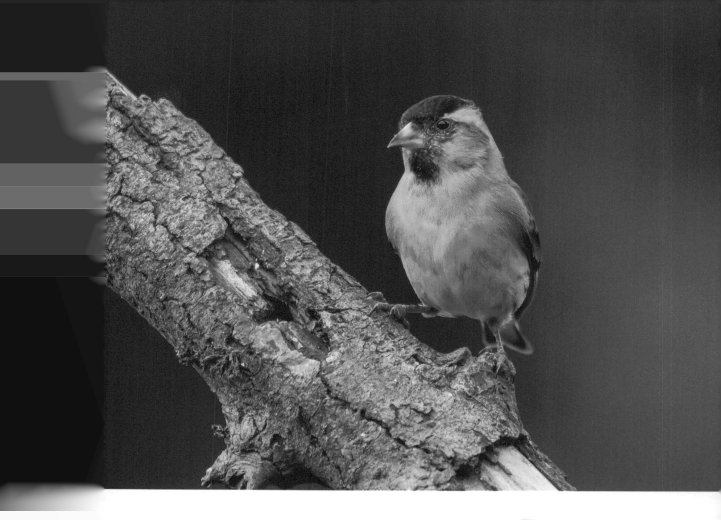

The Siskin is a small, lively finch which is smaller than a Greenfinch. It has a distinctly forked tail and a long, narrow bill. The male has a streaky yellow-green body and a black crown and bib. There are yellow patches on the wings and tail. It is mainly a resident breeder from southern England to northern Scotland, but it is most numerous in Scotland and Wales. Many breeding birds are residents; in winter, birds also arrive here from Europe.

DIMENSIONS (APPROX.):

- 12cm in length
- Weighing around 12-18g
- Wingspan of 20-23cm

DIET:

- Seeds, especially of conifers, alders and birch and some insects.

WHERE TO SEE THEM:

- We have visiting and resident Siskins here in Northern Ireland. In the breeding season, look for Siskins in the tops of trees.

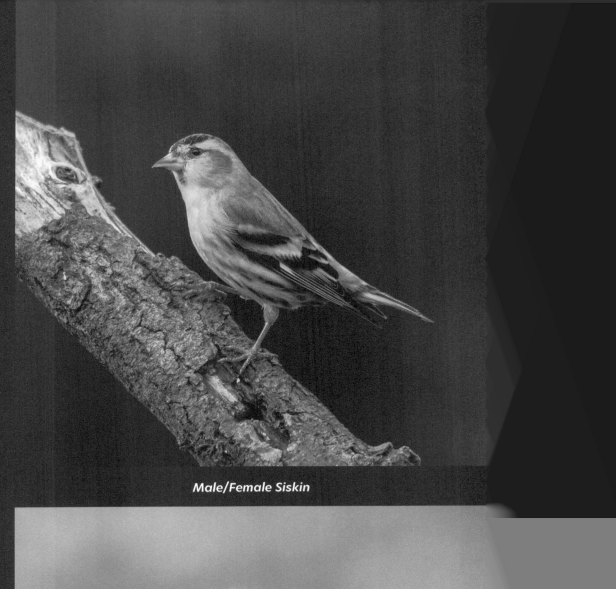

Male/Female Siskin

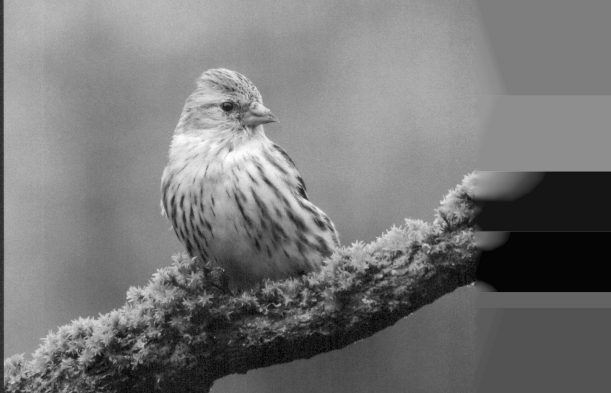

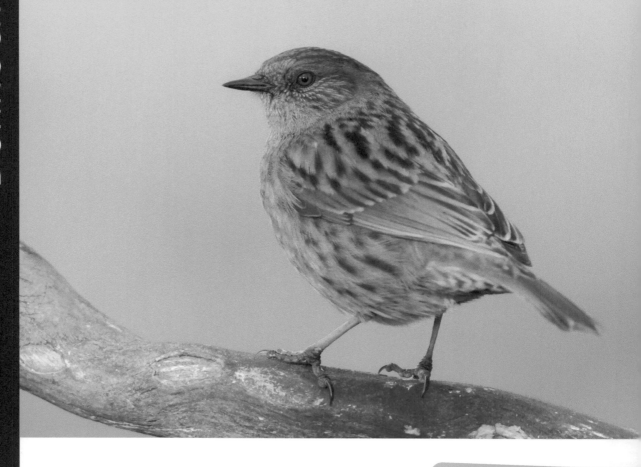

Dunnock

The Dunnock is a small brown and grey bird. Quiet and unobtrusive, it is often seen on its own, creeping along the edge of a flower bed or near a bush, moving with a rather nervous, shuffling gait, often flicking its wings as it goes. When two rival males come together, they become animated with lots of wing-clicking and loud calling.

When I was growing up, I always thought these birds were known as Hedge Sparrows.

DIMENSIONS (APPROX.):

- 14cm in length
- Weighing around 19-24g
- Wingspan of 19-21cm

DIET:

- Insects, spiders, worms and seeds.

WHERE TO SEE THEM:

- Dunnocks inhabit any well-vegetated areas with scrub, brambles and hedges. Look in deciduous woodland, farmland edges, parks and gardens. They keep largely on the ground and often close to cover.

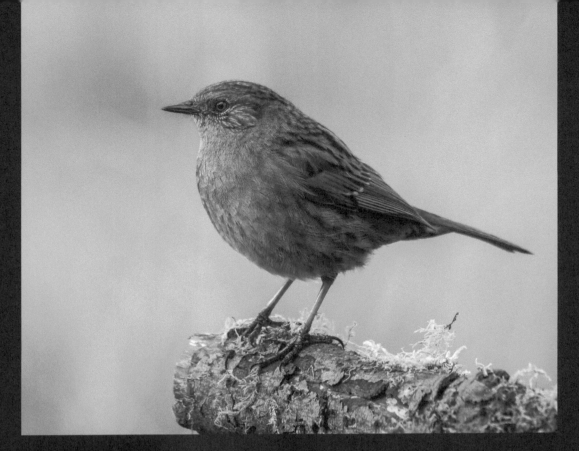

Adult and Juvenile Dunnock

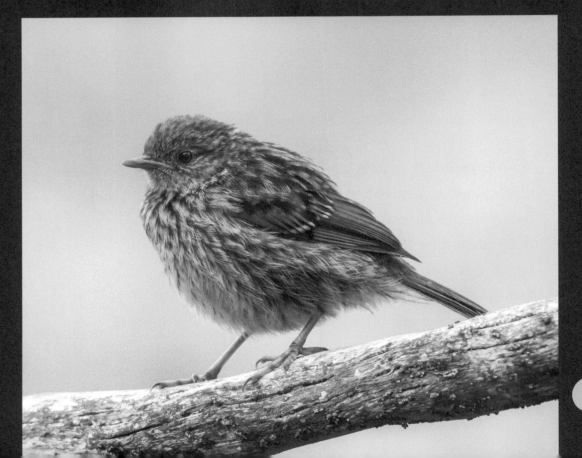

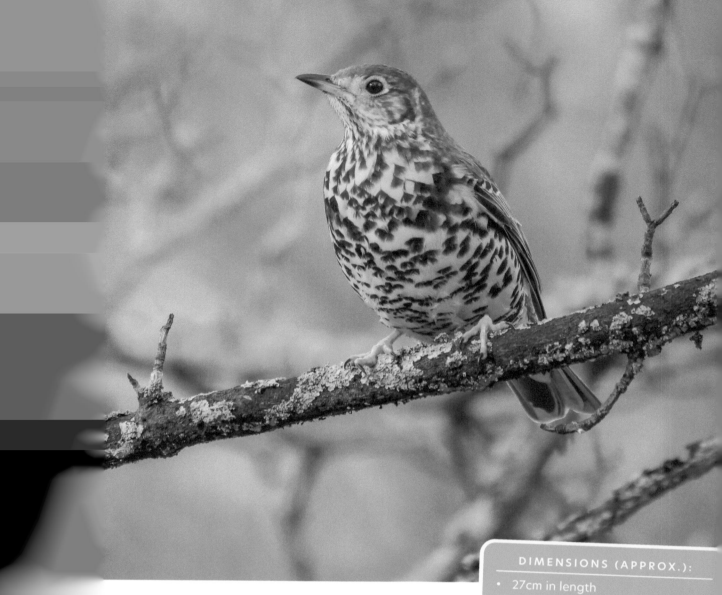

The Mistle Thrush is a pale, black-spotted thrush that is large, aggressive and powerful. It stands boldly upright and bounds across the ground. In flight, it has long wings, and its tail has whitish edges. It is most likely to be noticed perched high at the top of a tree, singing its fluty song or giving its rattling call in flight.

DIMENSIONS (APPROX.):

- 27cm in length
- Weighing around 100-150g
- Wingspan of 42-48cm

DIET:

- Worms, slugs, insects and berries.

WHERE TO SEE THEM:

- The Mistle Thrush is a widespread bird in the UK, found almost everywhere except on the highest, barest ground, and it is absent from the northern and western isles of Scotland. It can be seen in woodland, parkland and gardens.

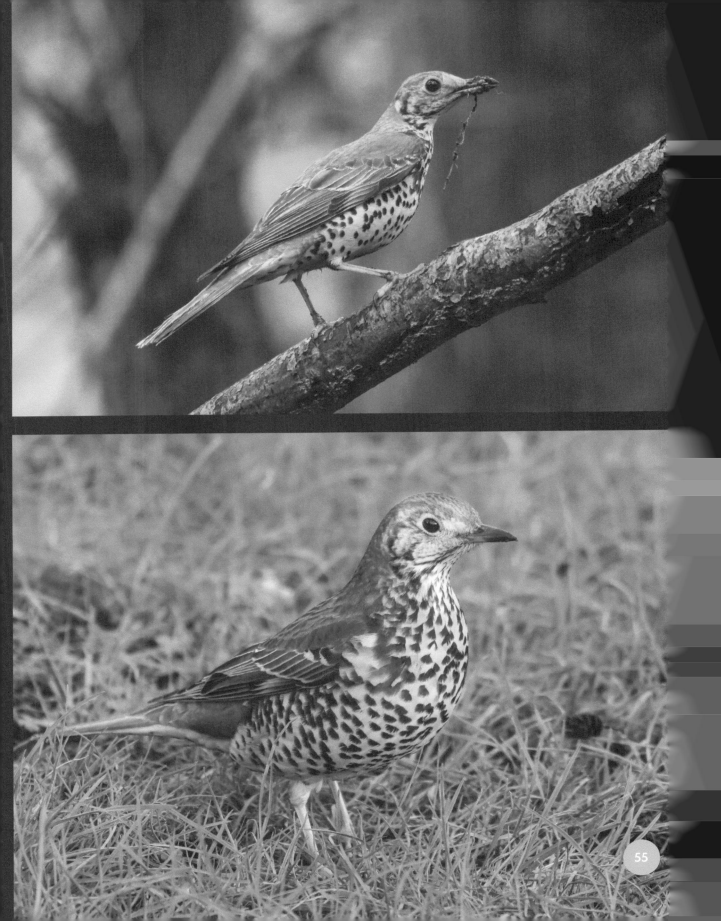

Reed Bunting

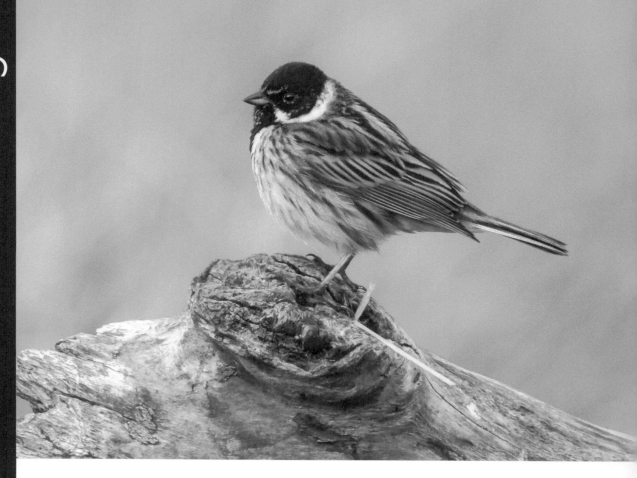

Sparrow-sized but slim and with a long, deeply notched tail, the male has a black head, white collar and a drooping moustache. Females and winter males have streaked heads. When in flight, the tail looks black with broad, white edges.

The Reed Buntings that visit the hide are from the neighbouring land. They forage in the rushes, but at times, they feed on the sunflower hearts.

DIMENSIONS (APPROX.):

- 14cm in length
- Weighing around 19-24g
- Wingspan of 19-21cm

DIET:

- Insects and seeds.

WHERE TO SEE THEM:

- Reed Buntings are predominantly a farmland and wetland bird. Typically found in wet vegetation but has recently spread into farmland and, in winter, into gardens. When singing, the male is usually perched on top of a bush or reed.

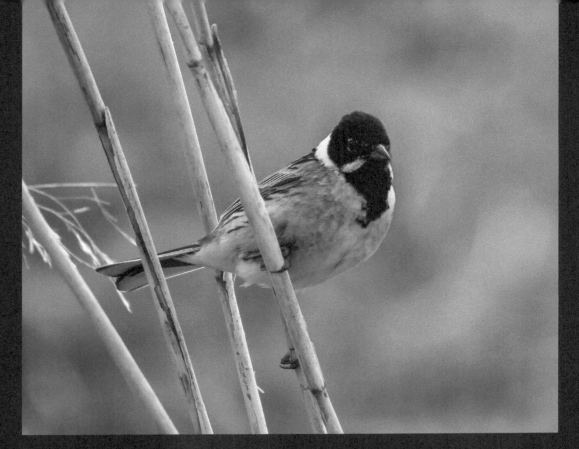

Male/Female Reed Bunting

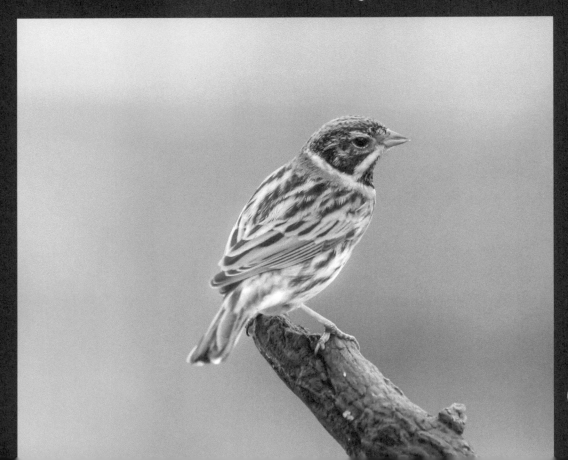

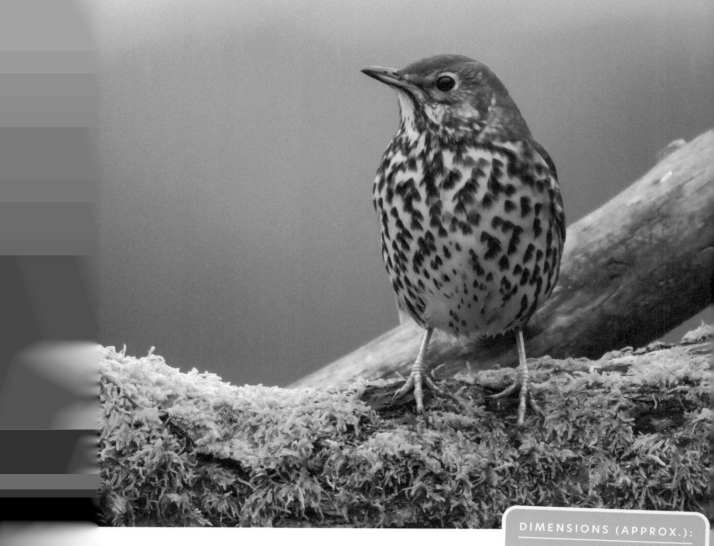

A familiar and popular garden songbird whose numbers has declined markedly on farmland and in towns and cities. It's smaller and browner than a Mistle Thrush with smaller spotting. Its habit of repeating song phrases distinguishes it from singing Blackbirds. It likes to eat snails which it breaks into by smashing them against a stone with a flick of the head.

DIMENSIONS (APPROX.):

- 23cm in length
- Weighing around 65-100g
- Wingspan of 33-36cm

DIET:

- Worms, slugs, snails, insects and berries.

WHERE TO SEE THEM:

- Woods, hedgerows, parks and gardens across the UK – you will find Song Thrushes wherever there are bushes and trees.

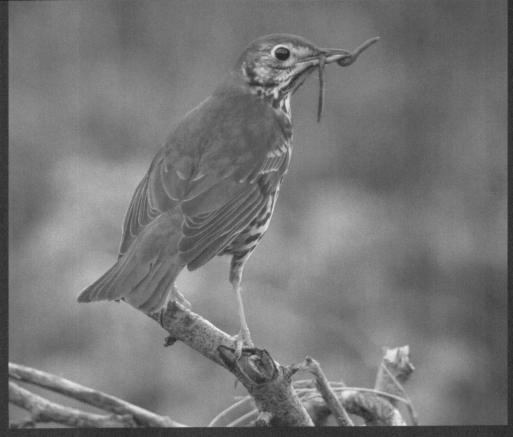

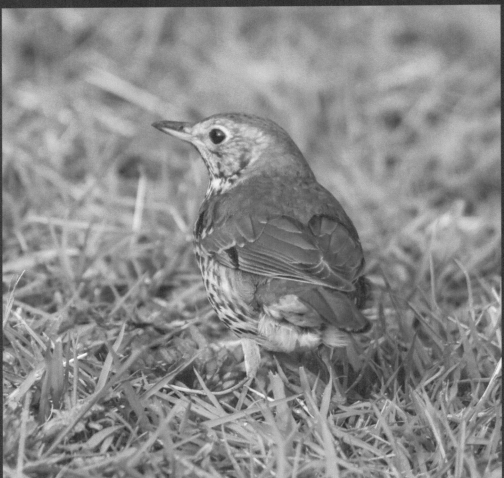

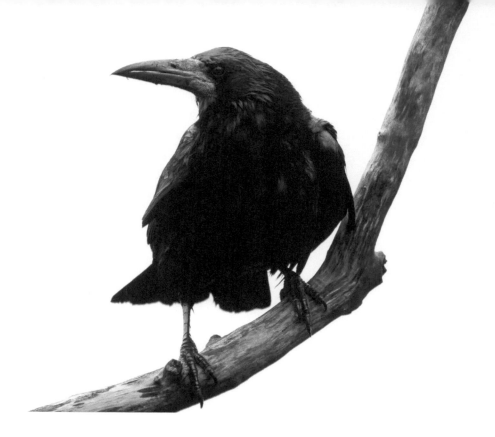

A bare, greyish-white face, thinner beak and peaked head make it distinguishable from the Carrion Crow. Rooks are very sociable birds, and you're not likely to see one on its own. They feed and roost in flocks in winter, often together with Jackdaws.

DIMENSIONS (APPROX.):

- 44-46cm in length
- Weighing around 280-340g
- Wingspan of 81-99cm

DIET:

- Rooks will eat almost anything, including worms, grain, nuts and insects, small mammals, birds (especially eggs and nestlings) and carrion.

WHERE TO SEE THEM:

- Rooks are usually seen in flocks in open fields or feeding in small groups along a roadside. They will come into town parks and villages but largely keep clear of the middle of big towns and cities.

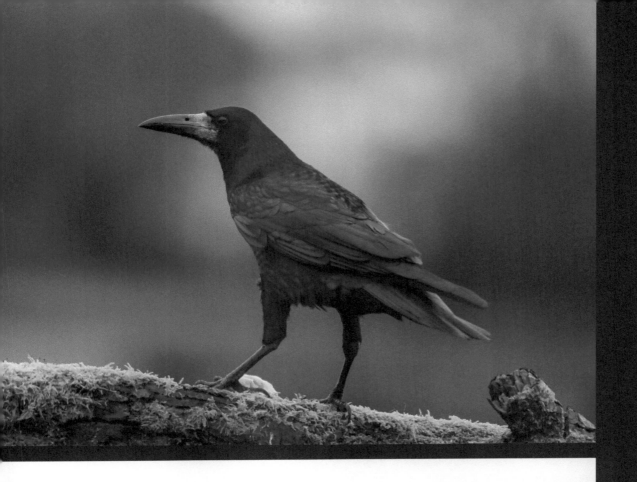

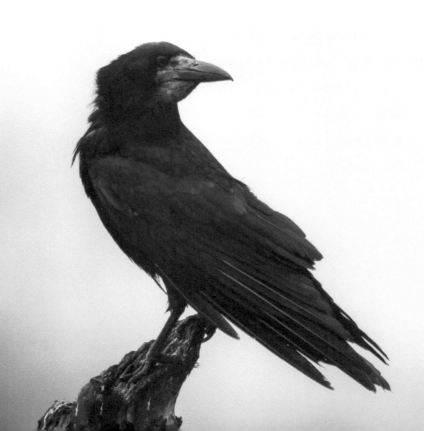

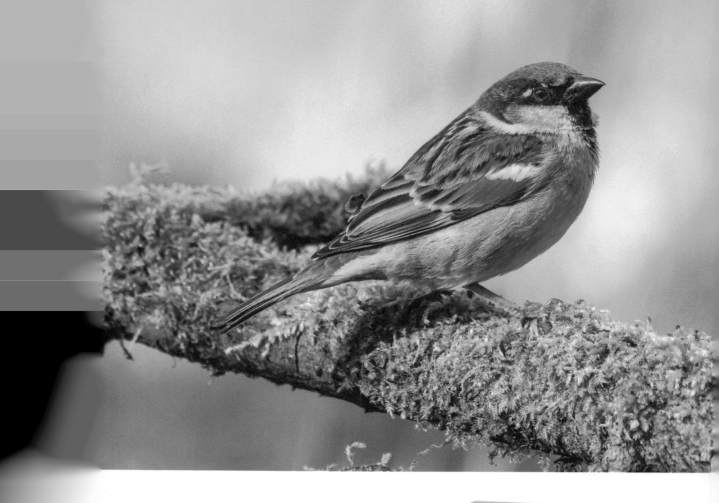

Noisy and gregarious, these cheerful exploiters of man's rubbish and wastefulness have managed to colonise most of the world and can be found in most cities and rural areas. House Sparrows like to stay in colonies and are very social birds.

DIMENSIONS (APPROX.):

- 14-15cm in length
- Weighing around 24-38g
- Wingspan of 21-25cm

DIET:

- Insects, seeds and they are opportunists where food is concerned.

WHERE TO SEE THEM:

- House Sparrows can be found from the centre of cities to the farmland of the countryside; they feed and breed near people. It is a species vanishing from the centre of many cities but is starting to make a comeback in rural areas.

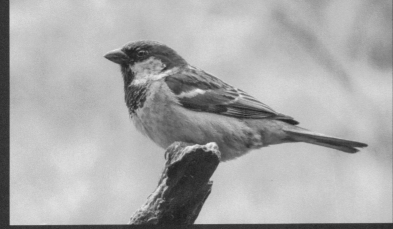

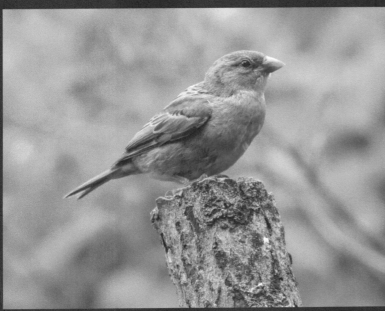

*Male/Female & Juvenile
House Sparrow*

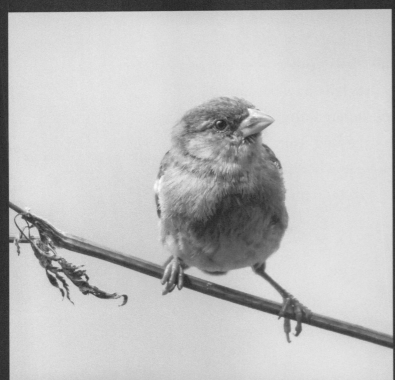

63

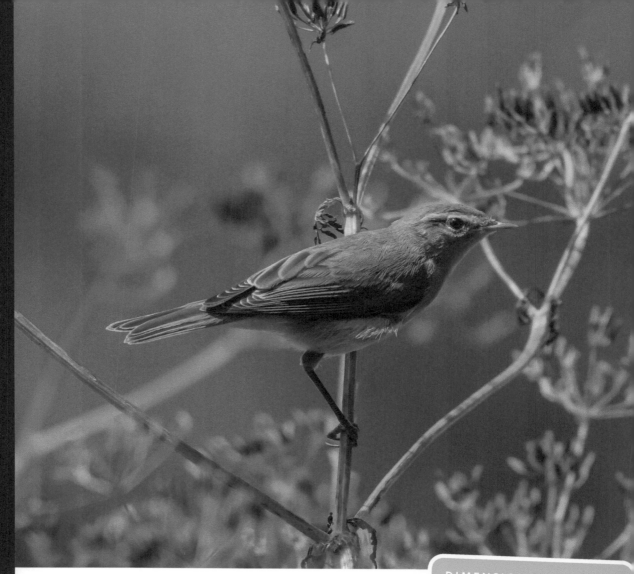

Willow Warbler (Summer Visitor)

Willow Warblers are small birds with grey-green backs and pale underparts. They have a yellow-tinged chest and throat and a pale supercilium (the stripe above the eye). They are separated from the very similar Chiffchaff by their song and leg colouring, as the Chiffchaff has black legs. I would put this down as a summer visitor.

DIMENSIONS (APPROX.):

- 10.5-11.5cm in length
- Weighing around 7-12g
- Wingspan of 16-22cm

DIET:

- A wide variety of small insects and spiders. Fruit and berries in autumn.

WHERE TO SEE THEM:

- Willow Warblers are widespread and can be seen in suitable habitats across most of the UK.

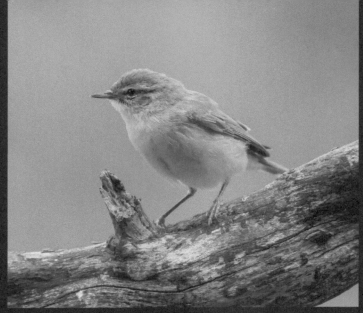

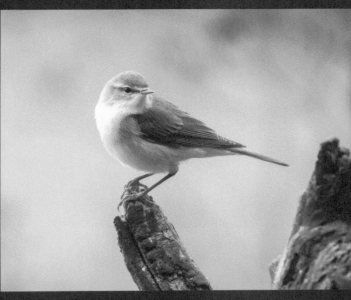

Adult and Juvenile
Willow Warblers

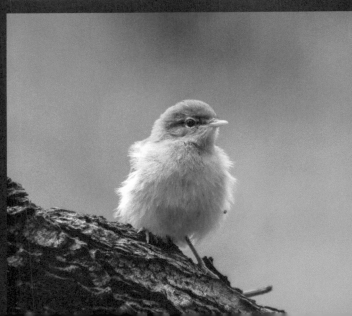

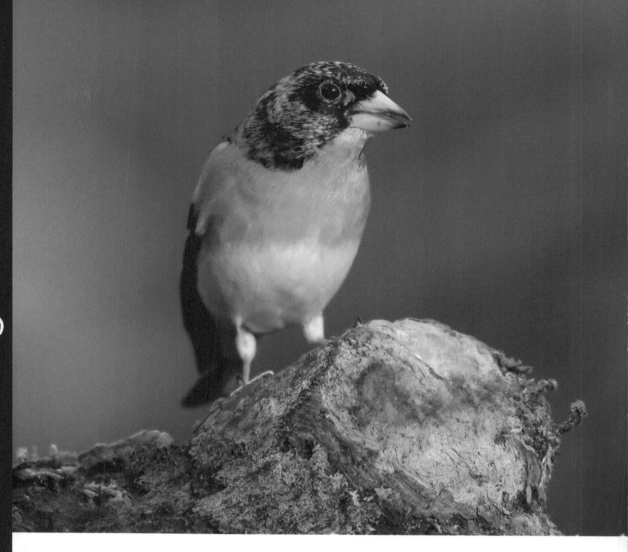

Brambling (Winter Visitor)

Similar in size and shape to the Chaffinch, again it may form flocks. The Brambling is a finch whose plumage changes considerably between summer and winter. In the winter, it has a black head, orange breast, white rump, and its upper parts are mainly black but mingled with orange. In the summer, the male has a glossy black head and back, and orange on its breast that extends round its back in a band. The female's summer plumage is the same as in the winter, but brighter.

DIMENSIONS (APPROX.):

- 14cm in length
- Weighing around 24g
- Wingspan of 25-26cm

DIET:

- Seeds in winter; insects in summer.

WHERE TO SEE THEM:

- In winter, Bramblings like beech woodland and farmland fields near woods. Look in flocks of Chaffinches and other finches. In autumn, they can be found along east coast woodlands and fields. Bramblings will also visit gardens in winter.

BIRDS FROM THE LOCKDOWN HIDE

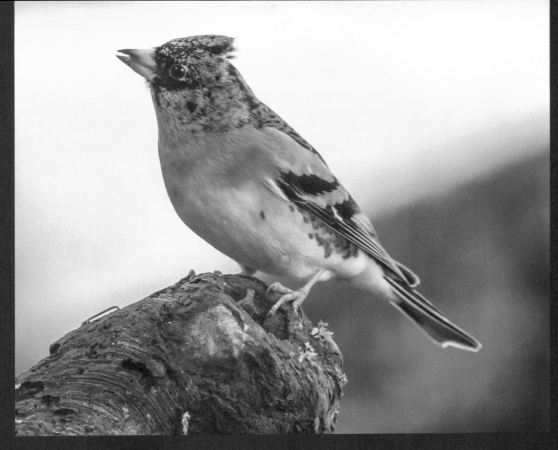

Male/Female Brambling

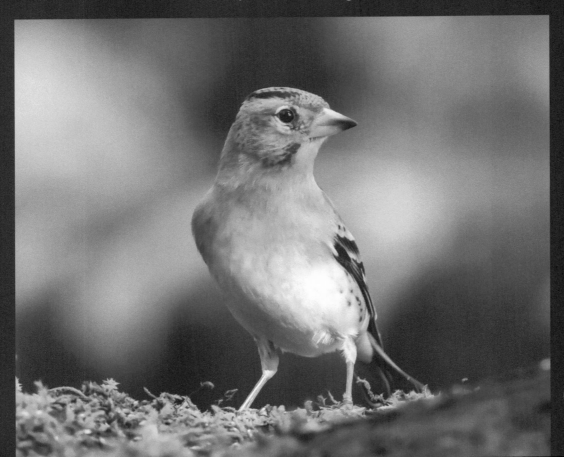

Fieldfare (Winter Visitor)

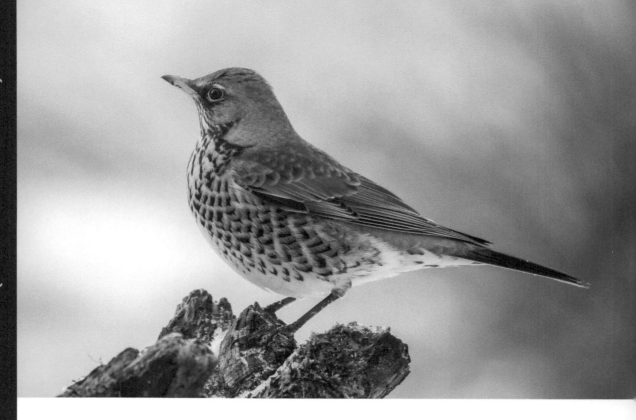

Fieldfares are large, colourful thrushes, much like a Mistle Thrush in general size, shape and behaviour. They stand very upright and move forward with purposeful hops. They are very social birds, spending the winter in flocks of anything from a dozen or two to several hundred strong. These straggling, chuckling flocks which roam the UK's countryside are a delightful and attractive part of the winter scene.

DIMENSIONS (APPROX.):

- 25cm in length
- Weighing around 80-130g
- Wingspan of 39-42cm

DIET:

- Worms, insects and berries.

WHERE TO SEE THEM:

- Fieldfares are best looked for in the countryside, along hedges and in fields. Hawthorn hedges with berries are a favourite feeding area. In late winter, grass fields, playing fields and arable fields with nearby trees and hedges are favoured places. They may come into gardens in severe winters when snow covers the countryside.

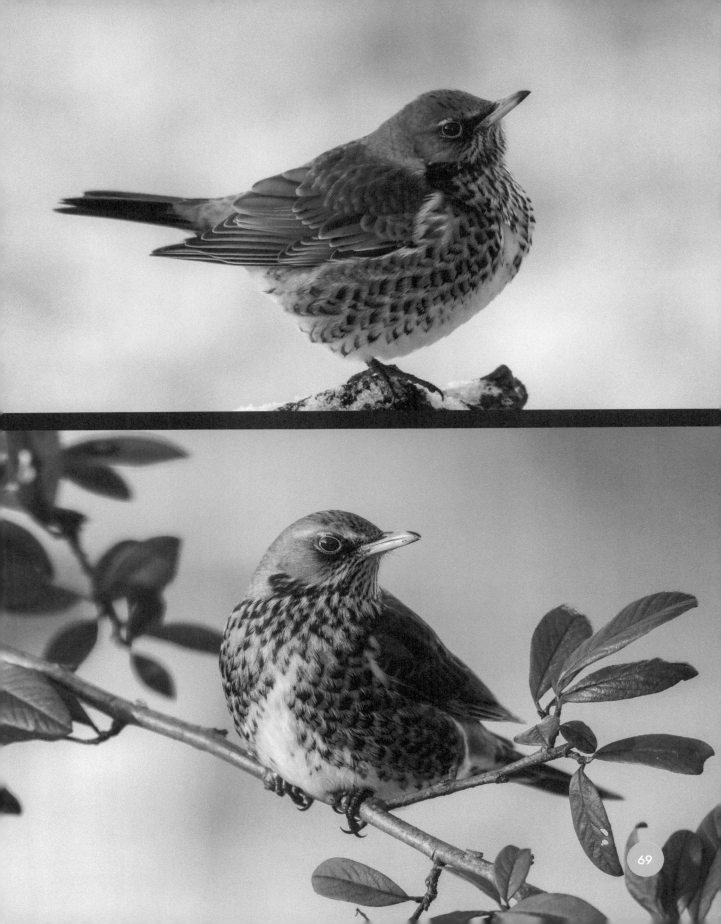

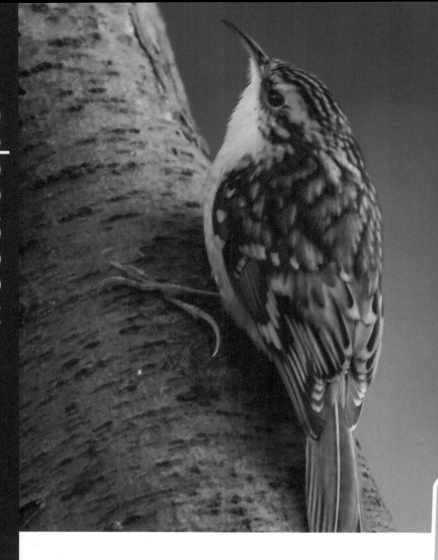

The Treecreeper is a small, very active bird that lives in trees. It has a long, slender, downcurved bill. It is speckly brown above and mainly white below. It breeds in the UK and is resident here. Birds leave their breeding territories in autumn, but most range no further than 20 km. Its population is mainly stable.

It is an elusive bird that is very well adapted to being invisible on tree trunks and branches, thanks to its plumage. It usually can only be seen when it moves or flashes its breast, which is white.

DIMENSIONS (APPROX.):

- 12cm in length
- Weighing around 8-12g
- Wingspan of 18-21cm

DIET:

- Insects and spiders and some seeds in winter.

WHERE TO SEE THEM:

- Treecreepers are best looked for on the trunks of trees in suitable woodland. In autumn and winter, they often join flocks of tits and other small birds, so if you come across such a flock in a wood, it is worth listening out for a Treecreeper among them.

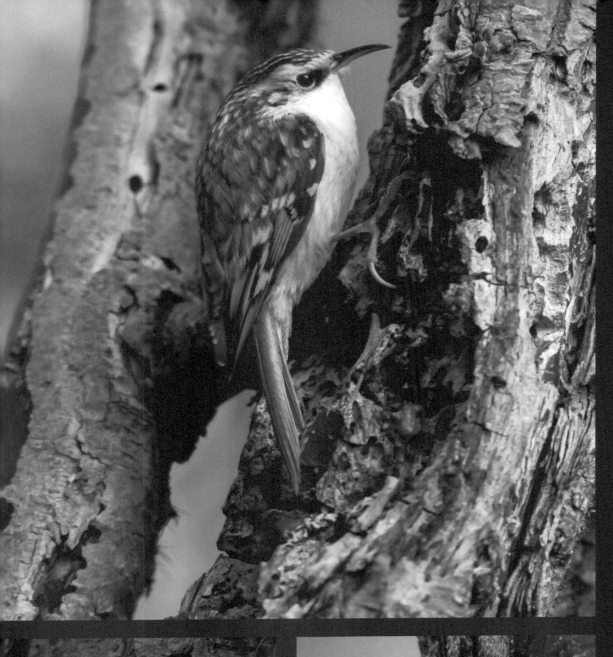

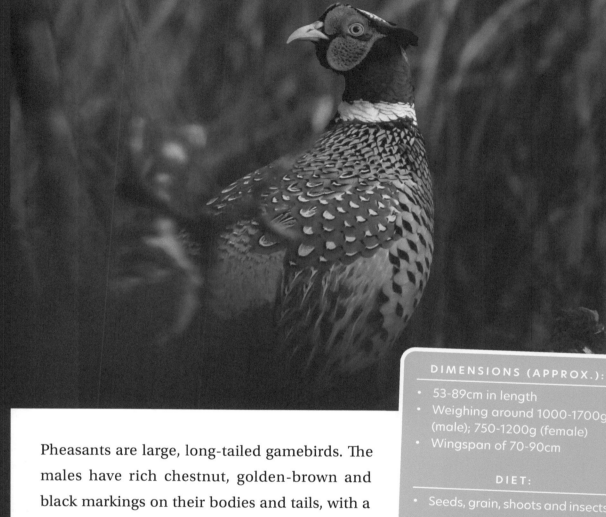

Pheasant

Pheasants are large, long-tailed gamebirds. The males have rich chestnut, golden-brown and black markings on their bodies and tails, with a dark green head and red face wattling. Females are mottled with paler brown and black. They were introduced to the UK long ago, and more recent introductions have brought in a variety of races and breeds for sports shooting.

DIMENSIONS (APPROX.):

- 53-89cm in length
- Weighing around 1000-1700g (male); 750-1200g (female)
- Wingspan of 70-90cm

DIET:

- Seeds, grain, shoots and insects.

WHERE TO SEE THEM:

- You can see Pheasants across most of the UK, apart from the far north and west of Scotland. They are least commonly found in upland and urban areas. They can usually be seen in the open countryside near woodland edges and hedgerows.

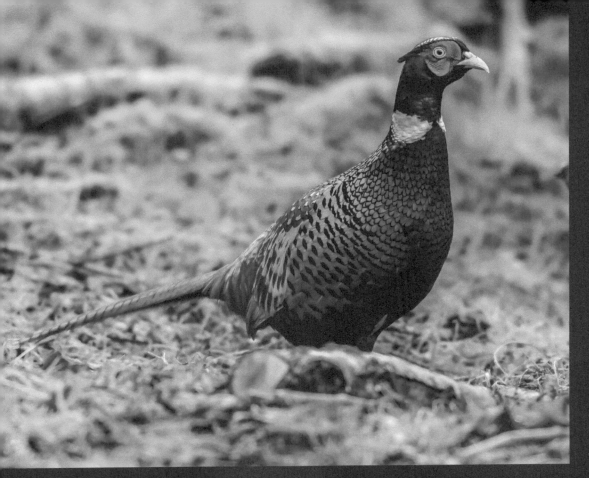

Male/Female Pheasant

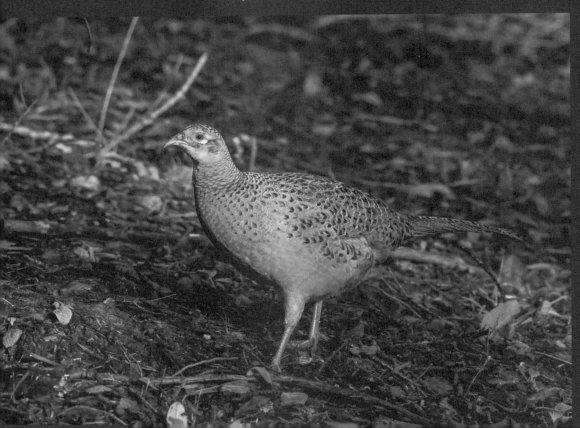

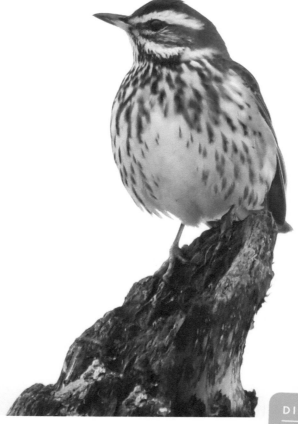

The Redwing is most commonly encountered as a winter bird and is the UK's smallest true thrush. Its creamy stripe above the eye and orange-red flank patches make it distinctive. They roam across the UK's countryside, feeding in fields and hedgerows, rarely visiting gardens, except in the coldest weather when snow covers the fields. Only a few pairs nest in the UK.

DIMENSIONS (APPROX.):

- 23cm in length
- Weighing around 65-100g
- Wingspan of 33-36cm

DIET:

- Worms, insects and berries.

WHERE TO SEE THEM:

- In open countryside, Redwings like hedges and orchards as well as open, grassy fields. They will come to parks and gardens and often join with flocks of Fieldfares.

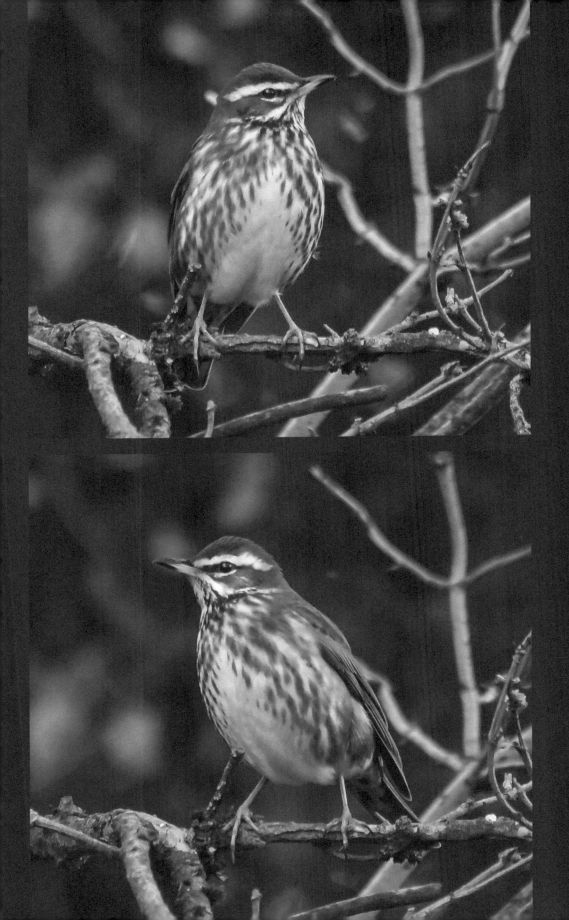

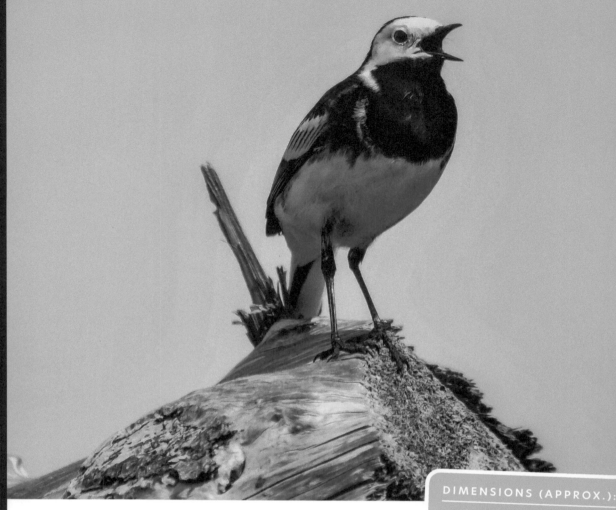

The Pied Wagtail is a delightful, small, long-tailed and rather sprightly black and white bird. When not standing and frantically wagging its tail up and down, it can be seen dashing about over lawns or car parks in search of food.

It frequently calls when in its undulating flight and often gathers at dusk to form large roosts in city centres.

DIMENSIONS (APPROX.):

- 18cm in length
- Weighing around 17-25g
- Wingspan of 25-30cm

DIET:

- Mainly insects but may eat seeds and household scraps in winter if put out for them.

WHERE TO SEE THEM:

- Pied Wagtails can be found across the UK. They are best looked for near water and can be found in most habitats, even town centres.

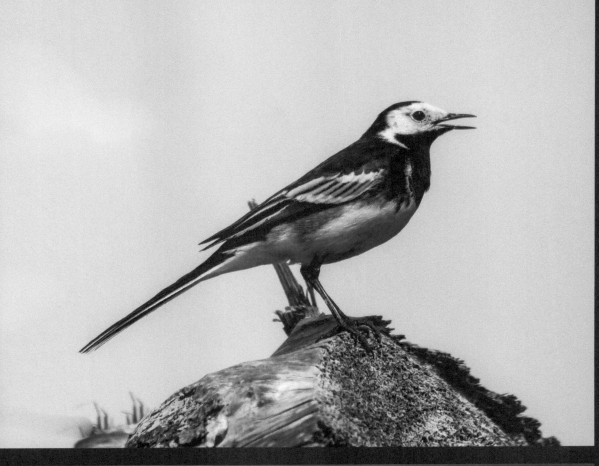

Adult

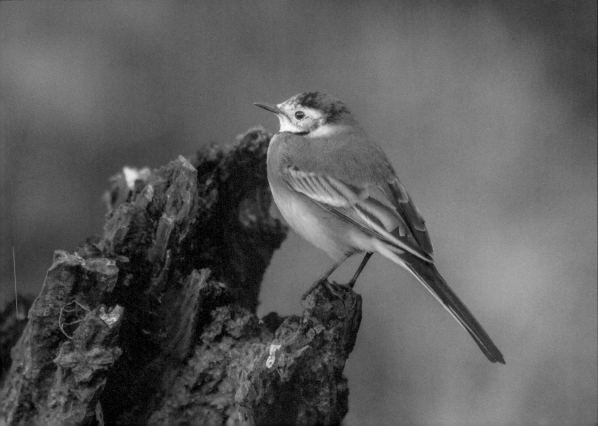

Juvenile

77

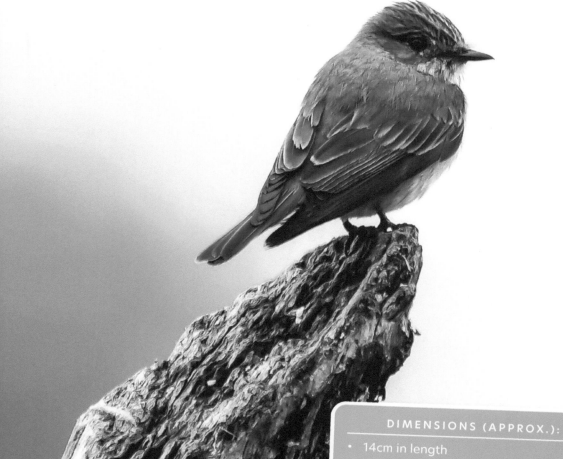

DIMENSIONS (APPROX.):

- 14cm in length
- Weighing around 14-19g
- Wingspan of 23-25cm

DIET:

- Flying insects, such as moths, butterflies, damselflies, craneflies and other tasty morsels. If the weather is bad, they can search trees and shrubs for other insect food.

WHERE TO SEE THEM:

- Churchyards, cemeteries, parks and mature gardens are good places. Spotted Flycatchers are often found in woodland with open fields – good for catching insects. During the breeding season, Spotted Flycatchers can be found throughout the UK, although they are scarce in the far north.

At first glance, Spotted Flycatchers might seem dull brownish-grey and, well, a bit boring. It's better to think of them as beautiful in an understated way. Watch them for a short period, and you will be charmed by their fly-catching antics. Spotted Flycatchers fly from a high perch, dash out to grab a flying insect and return to the same spot.

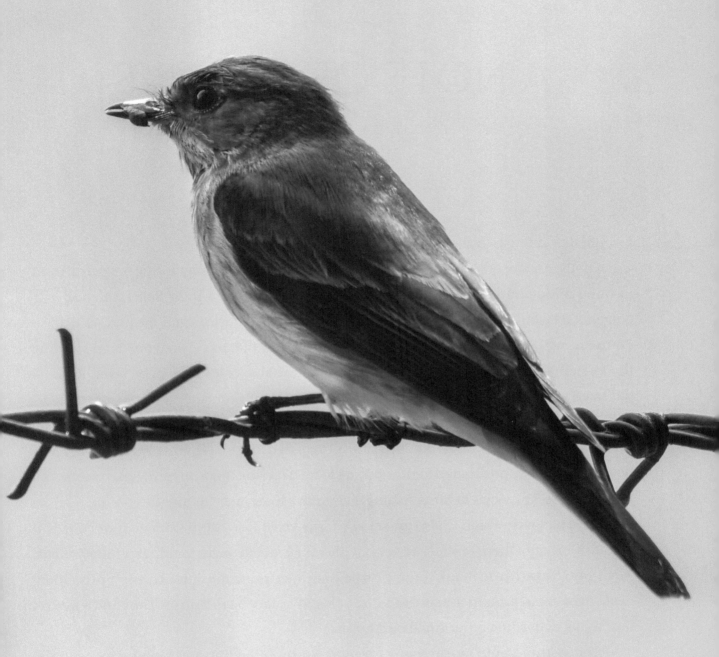

A NOTE OF THANKS

I would like to finish this journey by thanking a few people.

Firstly, my sincere thanks to Richard and his father, Eddie, for granting me permission to build a hide and a feeding station in the corner of one of their fields. Richard was convinced I wouldn't see much, maybe some Crows and Starlings and the odd small bird. I must admit I was pleasantly surprised with the variety that has visited and is still visiting the hide. Eddie (a young 93) has been amazed at what species have been seen. Even he has been educated, along with Richard, on some of the visitors they never knew existed.

As explained at the start of my book, I started with a hand-made shed, some feeding stations and a fresh-water feature. This soon progressed into tree stumps, logs and branches being strategically positioned for the raptors to feed on (the Buzzards and Sparrowhawks). As well as the 35 species of birds visiting, I also have mammals frequently coming, such as foxes and badgers, which is also great to see. The vixen last year produced four cubs and regularly brought them to feed – check out my social media pages for other photos/videos.

I would also like to thank Tommy for helping me around the hide at times and building nest boxes to put around the surrounding fields. We plan to erect an Owl box and a Kestrel box, along with some other small bird boxes.

And lastly I would like to thank Caroline for proofreading and helping me with the layout of the book.

You can follow me on Facebook at:
www.facebook.com/markwildlifeNI

or on Instagram at:
markswildlife

*I endeavour to put up daily posts on
both social media platforms.*

Lightning Source UK Ltd.
Milton Keynes UK
UKHW050454230922
409307UK00002B/117